Dr. S. Fritz Forkel
Kastanienstraße 24
D-61352 Bad Homburg
Tel. (0 61 72) 45 93 38

D1660897

Dr. S. Fritz Forkel
Kastanienstraße 24
D-61352 Bad Homburg
Tel. (0 61 72) 45 93 38

HAUDENOSAUNEE

Dr. S. Fritz Forkel
د. سليمان فريتس فوركل
ד"ר שלמה פריץ פורקל
Skén:nen Rón:nis

HAUDENOSAUNEE

PORTRAITS OF THE FIREKEEPERS
THE ONONDAGA NATION

TOBA PATO TUCKER

SYRACUSE UNIVERSITY PRESS

Copyright © 1999 by Syracuse University Press, Syracuse, New York 13244-5160

ALL RIGHTS RESERVED

First Edition 1999

99 00 01 02 03 04 6 5 4 3 2 1

The paper used in this publication meets the minimum requirements of American National Standard for Information Sciences—Permanence of Paper for Printed Library Materials, ANSI Z39.48-1984 ∞™

LIBRARY OF CONGRESS CATALOGING-IN-PUBLICATION DATA

Tucker, Toba.
Haudenosaunee : portraits of the firekeepers, the Onondaga Nation / Toba Pato Tucker.
p. cm.
ISBN 0-8156-0593-5 (cloth : alk. paper)
1. Onondaga Indians Portraits. I. Title.
E99.O58T83 1999
973'.04975–dc21 99-20287

Manufactured in the United States of America

For my daughter
DENA

*The publication of this book would not have been possible
without the generous support of*

THE GRAND MARNIER FOUNDATION

&

THE DANIELE AGOSTINO FOUNDATION

CONTENTS

FIGURES xi

FOREWORD: ETHICS & IMAGES xiii
OREN R. LYONS

INTRODUCTION 1
TOBA PATO TUCKER

ONONDA'GEGA': THE PEOPLE OF THE HILLS 9
CHIEF IRVING POWLESS JR.

PLATES 19

ONONDA'GEGA': ONONDAGA PEOPLE 107
AUDREY SHENANDOAH

ACKNOWLEDGMENTS 109

FIGURES

1 The old Longhouse, Onondaga Nation Territory 1991 4

2 The old Longhouse, Onondaga Nation Territory c. 1905 5

3 The new Longhouse, Onondaga Nation Territory 1991 6

4 Toba Tucker's photography studio in the old Longhouse,
 Onondaga Nation Territory 1991 7

5 The Iroquois Tree of Peace, painting by Oren R. Lyons 12

6 The Five Nation (Hiawatha) Wampum Belt 13

7 Seal of the Haudenosaunee, drawing by Oren R. Lyons 14

8 The George Washington Wampum Belt 17

FOREWORD
ETHICS & IMAGES

THE HISTORY OF A PEOPLE is in their faces. The mightiest government, in its final and fundamental essence, is its people.

When our people first saw the camera—the black box that captured our images—they said that it was dangerous, and that along with our images it captured our souls. The "civilized" people laughed at what they considered a naïve observation. But just how naïve is it?

There is much truth in this observation. Before the picture the subject was free and unencumbered. After the picture the photographer had indeed captured the identity of the person—his or her face. The photographer now had something he or she did not have before—the image and identity of another human being.

At this point the ethical question arises: What will the photographer do with the image? The subject is now at the mercy of the photographer and his or her ethical and moral standards. Presentation and caption will define how the public receives the image. Indeed, the black box had captured the essence, or *soul,* of the person.

Consider the "papparazzi," a contemporary term for unprincipled individuals whose livelihood is to capture famous people's images in compromising and unsuspecting situations. These individuals in turn sell the images to equally unprincipled newspapers and magazines for exploitation. This practice may well destroy a person's credibility and reputation, which in most societies is the essence of their well being and standing in the community.

This exploitation is not a new phenomenon. Many of the photographs of the famous Curtis collection, supported by J. P. Morgan in the early part of this century, were staged. They were subject to the interpretations of Edward Curtis. However innocent and well intentioned these interpretations were, they were nevertheless invasions and distortions of the person's soul. Today, contemporary and ethical standards of documentary photography demand informed consent from the subjects, because something is given and something is taken.

The association between the photographer and the person being photographed is most important. The confidence the subject has in the photographer will be reflected in the image. The difficulty of presenting the persona of the individual is extreme because the click of the camera is measured in milliseconds—an instant—a one dimensional image of a multidimensional human being. The purpose, perception, and sensitivity of the photographer to the subject will then determine the quality of image. Light and dark, chiaroscuro, are the tools of the black and white photographer. But what is far more important is the soul-to-soul relationship between these human beings. The genius of the image presented will be the completeness of the symbiotic relationship between the two people at the instant of the shutter's click.

When I look at old pictures of the last century, I study the faces of my people, of my relatives. I study the details of clothes and home. I search for information in backgrounds. I place names with faces and I see the continuing relationship between land and people, the continuity of life. I am pleased and grateful that someone back then understood the importance of record. These old pictures became treasures in our families and our Nation.

For the Haudenosaunee (the People of the Longhouse) and the Onondaga people, the family is the essence of our community. The strength and dignity of an ancient people continues to be reflected through our eyes, which are the windows of the soul. Some time tomorrow, generations from now, our progeny, the seventh generation, will be able to look back at this moment in time and see children who have become great-grandparents, and they will see the light of love in the eyes of our people and the determination not only to survive, but to pursue the future course of our people. And they can be grateful for the philanthropy of our good friend Michel Roux and the Grand Marnier Foundation, whose generosity and foresight made this project possible. And finally, they can be grateful for the perseverance, patience, integrity, and genius of Toba Tucker to record for the future this moment in the ongoing history of the Onondaga Nation.

<div style="text-align: right;">
FAITHKEEPER TURTLE CLAN

ONONDAGA COUNCIL OF CHIEFS

JOAGQISHO (Oren R. Lyons)
</div>

INTRODUCTION

My first Native American portrait was made by chance on the street in St. Paul, Minnesota. That was in 1977, not long after I began photographing. As I printed the Chippewa Indian's image, his face came up in the developer and captivated me—it was mystical, his expression undefinable and unknown to me. The mystery of his persona, as revealed in that photograph, prompted my decision to photograph Native Americans. Since then I have photographed the Navajo and Zuni in the southwest, the Shinnecock and Montauk Indians on eastern Long Island, the Onondaga Nation in upstate New York, and most recently, the artists and artisans of the pueblos in New Mexico and Arizona. Although my work is not exclusively devoted to Native Americans, they have been my primary subjects.

People often ask me why I photograph Native people, and I struggle to articulate my purpose. Collectively, Native Americans are an ancient people striving to retain their traditional way of life and integrity while confronting modern society and the dominant culture, and I want to record them for history and art at the end of the twentieth century. As individuals, they emanate an air of quiet wisdom and are a compellingly handsome people with strength and inner dignity written on their faces. I believe that this dignity is inherent in all people, but Native Americans seem to epitomize it and give it a visible presence that I try to present in my portraits. And, remarkably, they give me permission to do so, in spite of their usual reluctance to be photographed because they know Native Americans have been exploited by the camera throughout history. It is by our collaboration—I with my camera, they with their permission and cooperation—that we create the essential images by which their future generations, and the outside world, will remember them.

In 1991, at the conclusion of a project I was working on in Arkansas, Jeffrey Hoone, director of Light Work, a photography workshop located in Syracuse, invited me to be a

guest artist. Aware of my interest in photographing Native Americans, he told me that the Onondaga Nation Territory was less than ten miles from the workshop. Accepting his invitation, I decided to meet the Onondaga, anticipating the difficult task of gaining permission to photograph their people.

On my arrival in Syracuse, I attended a timely lecture at the Everson Museum given by Oren R. Lyons, Faithkeeper Turtle Clan, of the Onondaga Nation (plate 5). Oren Lyons explained that the Onondaga make decisions as a people, with the seventh generation always in mind; conscious of their thoughts and actions, they consider the effects of their decisions on the lives of their children living in the world of the future. After the talk I approached Oren Lyons and told him I would like to make portraits of the Onondaga Nation. He asked me why, and I replied so that the seventh generation of his people will know the faces of their ancestors. I had with me a small portfolio of my photographs, which Oren Lyons examined. He asked why the Onondaga should allow me, an outsider, to photograph them, especially since other photographers from various parts of the world have been denied this request. I did not feel the need to answer, but instead let my work speak for me. His eyes were dancing as he looked at the faces of the Navajo and Shinnecock, exclaiming when he recognized someone's portrait. He told me to come and meet the Haudenosaunee, "the people."

One of the first people I met on the Onondaga Nation Territory was a Clan Mother, Audrey Shenandoah, a handsome woman whose eyes reflect her wisdom, and whose quietly spoken words invite careful attention. I visited her in the classroom of the Onondaga Elementary School where she was teaching the Onondaga language to kindergarten children. Listening to the lesson, I thought the translation of Onondaga words to English was like poetry—the word for summer moon, *saskehah*, is expressed by the phrase, "when the light stays longer in the sky." After the class Audrey Shenandoah looked at my previous work and said yes, it was time to make another photographic record of the Onondaga Nation, which had been documented early in the century by Fred R. Wolcott of Syracuse. Wolcott's glass plate negatives, in the collection of the County Parks museum office for decades, were

restored and printed by David Broda of Syracuse University and published in the 1986 book *Onondaga: Portrait of a Native People*. A selection is displayed with great pride in the Onondaga's school entrance hall.

I was then taken to meet Chief Irving Powless Jr. (plate 36), an impressive, articulate man, who talked with me and questioned me for two hours. I expected this assessment of character by a spokesperson responsible for determining if individuals from the outside culture are trustworthy. (I have had experiences of this kind before, most memorably with the Navajo in the Arizona desert.) As requested, I wrote a letter and proposal for the project to Tohdadaho Leon Shenandoah (plate 1), for formal consent to work on the Territory. Permission was granted, and I began photographing in June 1991.

My first portrait was of Audrey Shenandoah and her daughters, Midwife Jessica Jeanne Shenandoah and Rochelle Brown, Eel Clan (plate 3). The photographing was to take place in a room of the schoolhouse on a Saturday. I use only natural light for all my work, and this was a fairly well-lighted, neutral place on the Territory. It was the first time I met Jeanne Shenandoah, whose presence and assistance were to become essential to the success of this project. We decided together on the arrangement for the portrait: Audrey and Jeanne seated, Shelley standing behind them. All my subjects make their own choices of clothing and adornments. Audrey was wearing a traditional style collar made for her by a well-known bead worker; Jeanne's collar belonged to her grandmother and aunt. They were also wearing contemporary, handmade clothing and jewelry. As I looked through the lens at the three women, tremendous power reflected back to me. I knew I was making what would be one of my strongest images, and felt I had little to do with it. Everything was emanating from the Shenandoah family, as though they were representing all the women in their clan history, before there were cameras to record their faces. When I finished photographing, I realized Chief Powless had come into the room quietly and was watching me work, as he would do many times. This was the start of the project.

I knew from previous experience working on Reservations that I needed a large, public

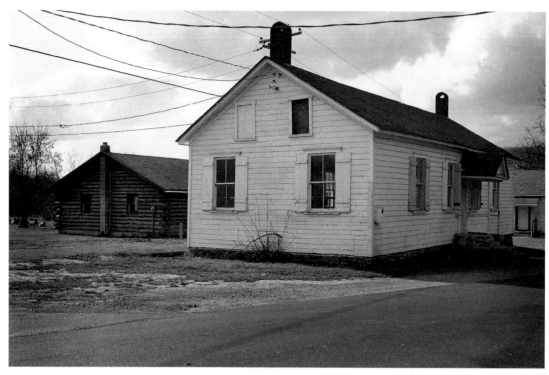

FIGURE 1 *The old Longhouse (new Longhouse in background), Onondaga Nation Territory 1991*

room familiar to the people, with good natural light in which to photograph; and one person to be a liaison for me with the community. My advisor was to be Jeanne Shenandoah, who learned her midwifery skills from her grandmother. A woman of inspiring composure and patience, she offered to work with me and facilitate the project. I am very grateful for all her assistance and advice, and her belief in what we were trying to accomplish together for the Onondaga. The time I spent with both Audrey and Jeanne Shenandoah is precious to me, not only because of what they taught me about themselves and their people, but because through them I learned about myself.

 The old Longhouse (figure 1) was offered to me as a place in which to photograph. I felt this was a great honor and a gesture of trust. The Longhouse is where traditional ceremonies, celebrations, and tribal meetings take place. Usually, strangers are not allowed to enter. The old Longhouse (figure 2), a white-painted wooden structure whose design reflects the region's late nineteenth century architecture, was outgrown by the expanding

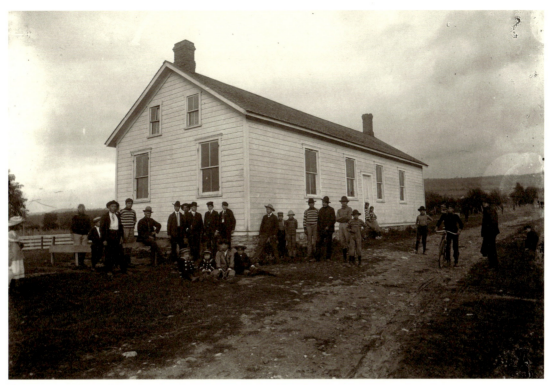

FIGURE 2 *The old Longhouse, Onondaga Nation Territory c. 1905*
Photograph by Fred R. Wolcott, courtesy of Onondaga County Parks, Office of Museums and Historic Sites

population of Onondaga. The new Longhouse (figure 3), much larger and built of logs like the traditional Longhouses of centuries ago, stands just behind the old one. Both buildings are heated with wood-burning iron stoves. The illumination inside the old Longhouse is beautiful, perfect for making portraits—the white-painted walls reflect the light coming in from the windows that surround the large room. I use a minimum of equipment: one camera (for this series a Hasselblad), two lenses, a 120 mm portrait lens and an 80 mm lens for group photographs, a tripod, and portable poles to hold a seamless, black paper backdrop. Jeanne collected some wonderful chairs for the people to sit on: two old oak armchairs found in the Onondaga firehouse, a bench borrowed from the new Longhouse, and an iron folding chair with the back missing from the cookhouse, which is an adjacent building used to prepare and serve meals to celebrate various occasions. I was very happy with this arrangement (figure 4).

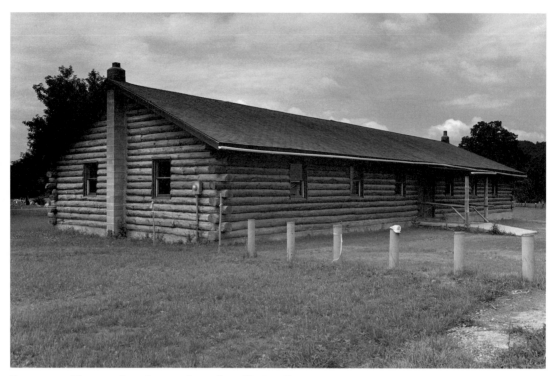

FIGURE 3 *The new Longhouse, Onondaga Nation Territory 1991*

Before photographing began, Jeanne took me to visit some of the elders on the Territory. She explained the project to the older members of her Nation in a quiet voice, using the Onondaga language. I knew the people needed to be convinced. I would sit and listen and observe, feeling privileged to be in the presence of these traditional people. With Jeanne providing the introductions, I gained the necessary acceptance. Eventually, I was able to arrange the photography sessions myself, making phone calls to encourage people, both young and old, to come to the old Longhouse to be photographed. Or, as we had hoped, people would come in on their own, since they were notified when I would be on the Territory, usually for a week or more at a time, from morning until the light diminished. Sometimes I would be there for days, in winter trying to keep warm by the wood stove started each morning by Edward Shenandoah (plate 6) and watched over by his son, Robert (plate 12), and no one would come in to be photographed. I would feel disappointed, and Jeanne would remind me to be patient. At other times, however, several large families would come in at

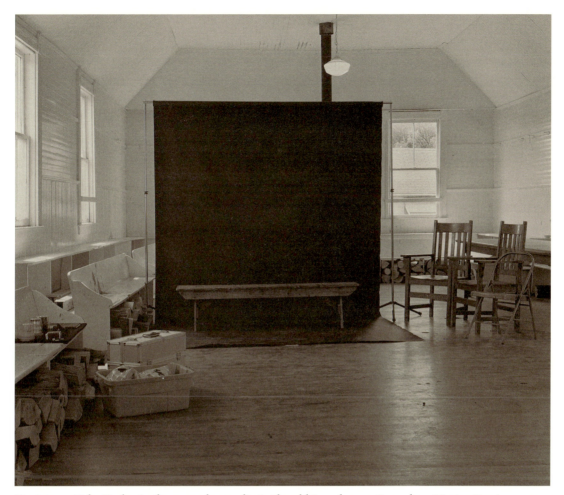

FIGURE 4 *Toba Tucker's photography studio in the old Longhouse, Onondaga Nation Territory 1991*

once. The Onondaga are family oriented, and many live in extended family households. Photographing them was a great pleasure but also challenging, for I not only had to focus intensely on making a portrait, but also had to keep track of exposed film, collect personal information so that prints of their portraits could be provided, and get signatures on photo releases. My portraits usually project an aura of composure, but many times this belies the chaos around me as I work.

During the almost two years I worked with the Onondaga, I had many rewarding experiences. Most memorable are the times I spent photographing while ceremonies were being performed nearby in the new Longhouse. Because it was so close, I could hear the

chanting of the singers, and the floor of my makeshift studio would vibrate with the rhythm of the dancers. I realized these were the same songs and dances that have been performed by the Onondaga people for hundreds of years. It was an extraordinary experience, and very inspiring. I was also deeply touched by the people's belief in me, their faith that I would use my camera respectfully. They and other Native Americans accept me because they sense the seriousness of my intent, which is to make an artistic statement that reflects their dignity and records it for posterity.

The Haudenosaunee, the Onondaga people, present themselves on these pages. Their portraits and their statements are here for the benefit of their seventh generation. I thank them for permitting me to make it possible.

The recent portraits of the Onondaga Nation that appear in this volume, made in 1991 and 1992, are framed and hanging in the corridors of the new addition to the Onondaga schoolhouse, alongside the vintage photographs taken of them in the early part of the century by Fred R. Wolcott.

<div style="text-align: right;">TOBA PATO TUCKER</div>

ONONDA'GEGA'
THE PEOPLE OF THE HILLS

KNOWN AS THE Onondaga Nation by the English speaking people, the Ononda'gega' live here in what is now central New York. We are the Firekeepers of the Haudenosaunee. The Haudenosaunee are known as the Iroquois Confederacy and the Six Nations; these are names given to us by the French and the English. We have lived here for many years in the land of our ancestors and continue to live by the ancient laws given to us by the Peacemaker.

The Peacemaker came to this country a few thousand years ago. He came at a time when there was much trouble on Mother Earth. The *Ongwehonwe* (people) who were placed here on Mother Earth had developed into people who were not acting in a manner that was consistent with the ways of the Creator. The Onondaga were fighting among themselves and with their neighbors the Oneida, Cayuga, Mohawk, and the Seneca. This fighting was not acceptable to our Creator. The Peacemaker was then sent to us.

In a village in what is now Canada, a boy was born. This boy would become the Peacemaker. He had received his instructions and he spent time in the woods preparing himself for his journey. He grew and became a young man. He had made himself a canoe out of stone and the time had come for him to depart. He called his mother and grandmother to the shore of what is now Lake Ontario and said that he would be leaving. He would not return to them. They thought that the canoe would not float because it was made of stone, but the young man assured them that it would and so he got into the canoe and paddled away.

He came into the territory of the Onondaga and there he met a man named Haionwhatha. He explained that he had a message of peace and the people should live this way—

they should not be killing each other but instead should live in peace. Haionwhatha accepted the message and agreed to help the Peacemaker on his journey of peace. Haionwhatha had just lost some of his daughters and was grieving his loss. He thought that there must be some way that people could be helped at a time like this. It was at this time that the words of condolence were first spoken. These words are still used today when our people lose a relative. These words are used when we raise one of our men to be a leader of his Nation. These words are very important to the spiritual well being of our people.

The Peacemaker's message was of peace. We should be able to settle our disputes between us peacefully, and not with violence. He gathered the people together and explained how we should conduct ourselves. He divided the people into clans and then gave us a system to raise leaders for these clans. There would be men and women leaders and they would have people to assist them. Today these people are known as Chiefs, Clan Mothers, and Faithkeepers. They have the responsibility of teaching and passing on the history and traditions of the people. The process for selecting and putting a person into the place of leadership was explained to us by the Peacemaker, and that system is still followed today. The Peacemaker explained that it would be better for us to join together so that we would be able to protect ourselves better, rather than to be separate Nations.

The Peacemaker traveled from one Nation to the next explaining his message of peace. The Nations accepted his message and joined together. The last Nation to join was the Onondaga. The Onondaga were necessary because the union of Nations would not work unless they were a part of the union. One of the key persons in the formation of this union was an Onondagan named Tohdadaho. He was a man of great power and was feared by the people. He had rejected the message at first, but the Peacemaker informed Tohdadaho that he would have special duties in this union of Nations and preside over the grand council of the Haudenosaunee, and so Tohdadaho agreed.

This event happened on the shores of a lake that is now known as Onondaga Lake. On the east shores of this lake, the Peacemaker uprooted the great white pine, and into the

cavern where the roots had once grown the Nations threw their weapons of war. The stream of water flowing through this cavern carried away the weapons of war. They would never war against each other again. The Peacemaker then placed the white pine back in its place, and on top of the tree he placed an Eagle. The Eagle is able to see great distances and it would be able to warn us if any danger were to come towards us. The roots of the tree would be called the white roots of peace and would go out in the Four Directions. If in the future any Nation of people lost their way, they could follow these roots back to the Tree of Peace and take shelter under the tree (figure 5).

The Peacemaker explained that we were all one family. Each of the Nations was given clans and each clan member would be related. There are three clans that are in each of the Nations. They are the Wolf, Bear, and Turtle. This means that if an Onondaga Wolf travels to the Mohawk he can seek shelter with his relatives in the Wolf Clan of the Mohawk Nation. We would live in one big house and the Mohawk would be the Keepers of the eastern door, and the Seneca would be the Keepers of the western door. The Onondaga would be the Firekeepers of this house. We would all be known as the Haudenosaunee, the People of the Longhouse. This is what we were known as, but when the French came to this country they called us the Iroquois and the English called us the Five Nations. In 1724 the Tuscarora were driven out of their homes in what is now North Carolina and they came to live with our ancestors. After that time the English called us the Six Nations. Sometimes people refer to us as the Six Nations Iroquois Confederacy, but we have always called ourselves Haudenosaunee (figure 6).

The Peacemaker placed nine leaders among the Mohawk, who were the first ones to accept his message of peace. He placed nine leaders among the Oneida. He placed ten leaders among the Cayuga and eight leaders among the Seneca. He placed fourteen leaders among the Onondaga, making the total number of leaders among the Haudenosaunee fifty. He gave us a process and procedure for replacing our leaders, both men and women. He gave us a way to conduct ourselves that would ensure we would endure through time. He gave us a

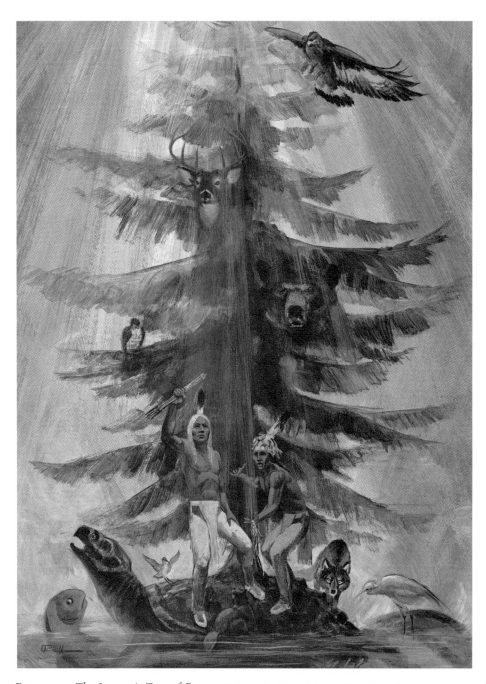

FIGURE 5 *The Iroquois Tree of Peace* Painting by Oren R. Lyons, Onondaga Nation

The painting of the Tree of Peace shows the Great Peacemaker and his messenger, Haionwhatha (Hiawatha), standing at the Tree of Peace on Great Turtle Island. The Peacemaker holds a bundle of five arrows that symbolizes the Five Nation Confederacy and carries the message that strength comes from unity, while Hiawatha (right) carries five strands of wampum, one for each nation—the Seneca, Cayuga, Onondaga, Oneida, and Mohawk. The eagle appears at the top, where it is watching and protecting the nine clans—Turtle, Eel, Bear, Snipe, Wolf, Heron, Beaver, Deer, and Hawk.

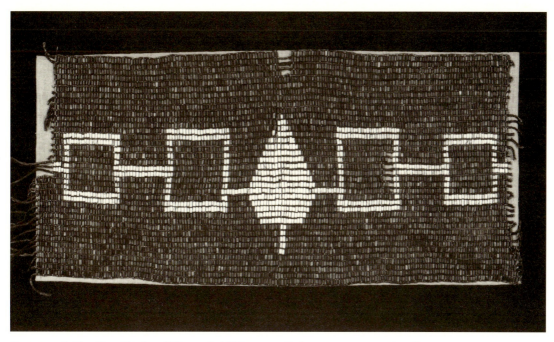

FIGURE 6 *The Five Nation (Hiawatha) Wampum Belt* Courtesy Onondaga Nation archives

This belt symbolizes the unification of the Nations of the Haudenosaunee. The four rectangles and the Tree of Peace represent, from west to east, the Seneca, Cayuga, Onondaga, Oneida, and Mohawk Nations. In the 1720s, the Tuscaroras joined, and the Haudenosaunee became Six Nations.

method for sitting in council and taking care of the everyday problems. He gave us a method for meeting foreign nations and dealing with the problems that they might bring. All of these methods, processes and procedures, and messages are still used today by the Haudenosaunee. We continue to live within the laws that were given to us so many years ago. The Mohawk and the Oneida were given three clans. The clans are Wolf, Turtle, and Bear. The Cayuga were given five clans. The clans are the Wolf, Turtle, Heron, Snipe, and Bear. The Senecas were given eight clans. The clans are the Wolf, Bear, Beaver, Turtle, Heron, Hawk, Snipe, and Deer. The Onondaga were also given eight clans. The clans are the Wolf, Beaver, Turtle, Snipe, Hawk, Eel, Deer, and Bear (figure 7).

The system that was given to us to be used when we dealt with the other Native Nations was also used when the Europeans came into our territory. We noticed that they were in need of our assistance and that they needed a place to live. They had a different concept of the land than we did, but nevertheless we sat with them and decided how we would

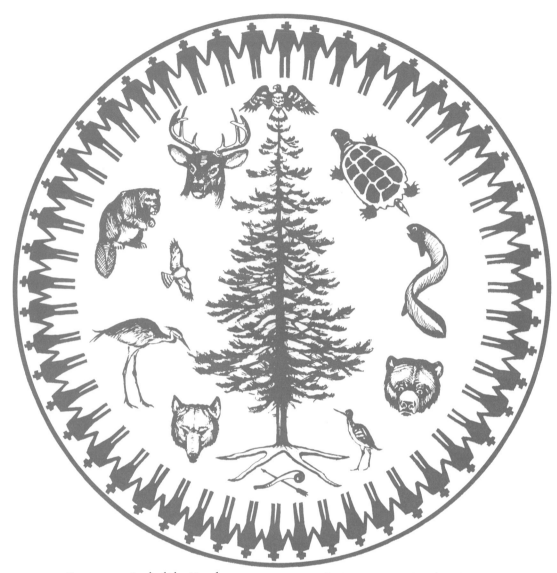

FIGURE 7 *Seal of the Haudenosaunee* Drawing by Oren R. Lyons, Onondaga Nation

The Tree of Peace is at the center of the Confederacy. Its four roots stretch north, south, east, and west to provide paths of peace that guide all people who seek shelter under the Great Law of Peace. Weapons of war (the club and arrow) are buried below the tree, and the Eagle, above, watches for danger. The Tree of Peace is surrounded by all the Iroquois clans—Turtle, Eel, Bear, Snipe, Wolf, Heron, Beaver, Deer, and Hawk. The circle of Chiefs encloses the Nation, its laws, and its people.

share the gifts of the Creator here on Mother Earth. This first agreement was made around 1613 with the Dutch people. This agreement was recorded in our way and is known as Gaswenda—the Two Row Wampum Belt. The agreement allows us to live together in peace

and friendship forever, "as long as the grass grows green, the water flows downhill, and the sun rises in the east and sets in the west." This is where these words were first spoken and have endured throughout time, for this phrase is still used today. Similar words were put in the treaties that the United States made with the Natives from 1771 until they stopped making treaties in the 1880s.

The Two Row Wampum Belt is a belt of white wampum with two rows of purple wampum beads running parallel to each other, which are separated by three rows of white beads. The two rows of purple beads represent the boat of the white man and the canoe of the Native people. The three beads in between the purple beads represent peace, friendship, and forever. The purple beads never cross but travel parallel to each other and represent the statement that the people in the boat and the people in the canoe will never pass laws to govern the other. The Haudenosaunee have never violated this concept. We have never passed a law that would tell the whites what they can or cannot do. The whites, on the other hand, violate this concept every day. They have passed laws not only at the federal level, but also at the state level. There are law books full of laws that tell the Natives what they cannot do. Sometimes the laws tell us how we cannot carry on with the practicing of our way of life (religion) because there is some aspect of our way that the whites do not understand.

The coming of the Europeans brought many changes in the lives of the Haudenosaunee. It also brought into the minds of the Europeans concepts that they had never heard of or rights that they had not experienced, such as the freedom to meet and discuss their own future, to voice their opinion at such a meeting, and to practice whatever religion they wished. The Natives they met all had these rights and talked about them freely. The Europeans then understood what freedom meant. They looked at our laws and our system of government. They sent representatives to meet with our leaders to see how this system worked. Benjamin Franklin was one of these people. Our leaders suggested to the people that it would be to their advantage to form a union of their fires as we had done so many years before.

The colonists living under the rule of England finally had enough of English rule and wanted to be free people. They revolted against England and the Revolutionary War was the result. The Haudenosaunee were a mighty military force, and the revolutionaries did not want the Haudenosaunee to be fighting on the side of England, so they sent the first federal Indian agent out to neutralize the Haudenosaunee and their allies. In 1775 at Fort Pitt, the federal agent George Morgan met with the Haudenosaunee and their allies. There were fifteen hundred Native people at this meeting. The end result was a treaty of neutrality. The Haudenosaunee agreed to this treaty, as did their allies, to remain neutral during the upcoming war.

Though the Haudenosaunee were neutral, some people of the Nations fought with the English and some fought with the revolutionaries. After the war, the Haudenosaunee were still a problem. President George Washington did not have the funds to pay his soldiers, so he paid them by giving them some of the land of the Haudenosaunee. He had no title to the land that he gave away. President Washington decided to extinguish the Haudenosaunee, and he sent out Major General John Sullivan to do the job. Sullivan failed in his mission. He destroyed our towns, our villages, and our crops. He did not destroy our people. The people gave George Washington a name for doing what he did. They call him Hanadaguis, which means Town Destroyer. General Sullivan succeeded in making the Haudenosaunee irritated. The Haudenosaunee went out to destroy the homes of those who had come into their territory. George Washington could not afford a war with the Haudenosaunee, and he could not defend his people. The only way that there could be peace was to make an agreement.

After many meetings it was agreed that the fighting would end and the two sovereigns sat down to negotiate. This negotiation resulted in the signing of a treaty at Fort Stanwix in 1784. The western boundary line of the Haudenosaunee was drawn at this time. There were goods given to the Haudenosaunee, but these goods were not the payment for the land that the Haudenosaunee gave to the United States. The Haudenosaunee, as a free country, had the capability to give away this land. There was no money given at this time, and the land turned over to the federal government developed into eleven states of the United States.

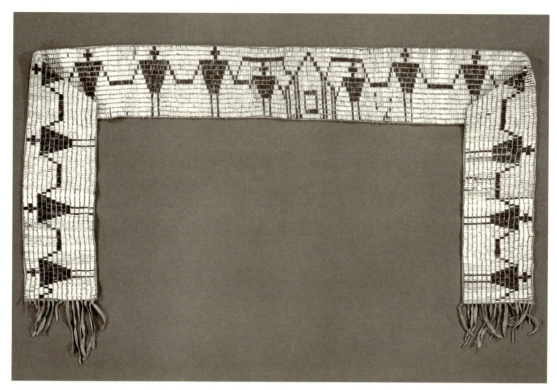

FIGURE 8 *The George Washington Wampum Belt* Courtesy Onondaga Nation archives

The George Washington Wampum Belt was made to symbolize the 1794 Treaty of Canandaigua. The thirteen figures represent the thirteen original colonies. The two small men represent the Seneca and Mohawk. The house represents the Haudenosaunee, the People of the Longhouse. Their hands are joined because the treaty calls for peace and friendship.

This exchange did not end the turmoil, and the United States and Haudenosaunee sat down two more times, once at Fort Harmar in 1789 and again at Canandaigua, New York, on November 11, 1794 (figure 8).

These three treaties between the Haudenosaunee and the United States confirmed the sovereign status of our land and of our people, and definite boundaries were drawn between us. The lines that were drawn were not to keep our people in, but instead they were to keep the Europeans out of our lands. But there were intrusions into our territory, and our ancestors kept complaining about this to the President George Washington. He responded by having a federal law passed that would protect our lands. This law, known as the Non-Intercourse Act of 1790, says that no lands will be taken from us without someone from the federal government being present at the time.

This law was ignored by the surrounding states, including New York State, and they made treaties with other Indian Nations regarding our territory. As a result, large tracts of our land were taken from 1784 through the 1800s. This resulted in the Onondaga Nation putting land claims into the courts for restitution of land taken illegally.

There have been many changes in our land since the arrival of the Europeans. Some of the changes have been good and some of the changes have not been good. Many things have changed. Many things have not changed. The Haudenosaunee still carry on the ways of our ancestors in the same manner as our ancestors. The ceremonies, speeches, songs, and concepts have not changed. The Onondaga, the name we are known by today, still live on the land surrounded by hills and are still known as "the People of the Hills." —*DAWNAYTOH*

CHIEF IRVING POWLESS JR.
WOLF CLAN

PLATES

Tohdadaho Leon Shenandoah

1915–1996

Honored, beloved leader of the Haudenosaunee and of many peoples far and wide. He passed on from this earth to the Creator's land, but he will always be with us in heart and will remain in the memory of all who knew him. Gentle and firm were his ways as he walked in a balance in ever-changing times.

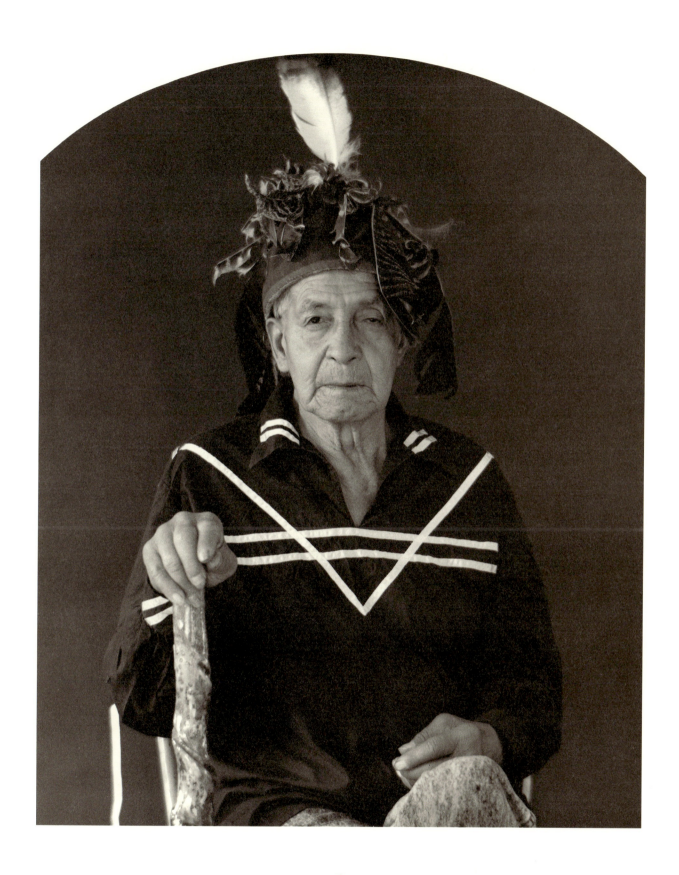

I

LEON SHENANDOAH

TOHDADAHO

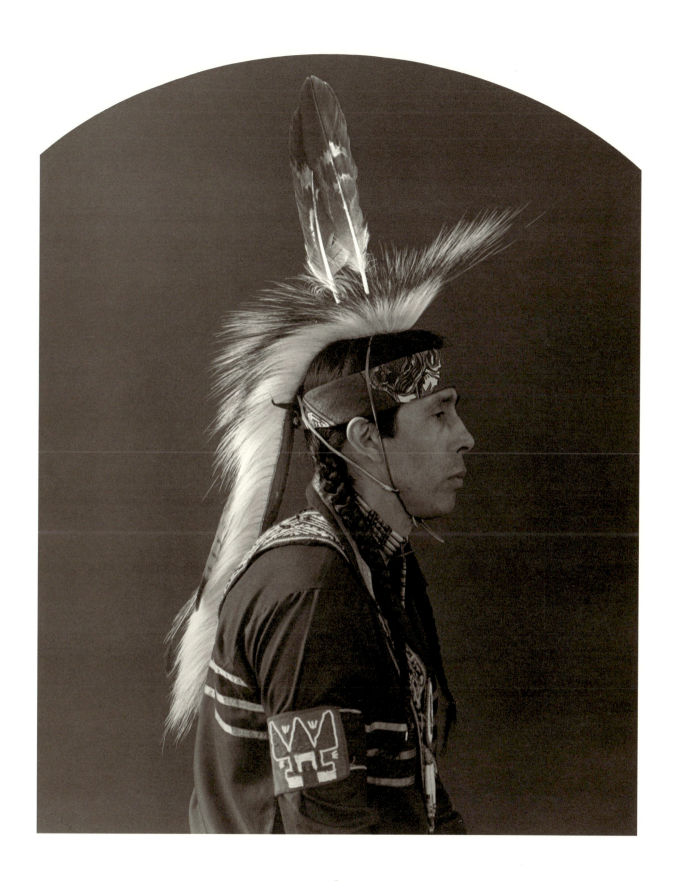

2

FAITHKEEPER SIDNEY HILL, Eel Clan

Faithkeeper Phoebe Hill's son

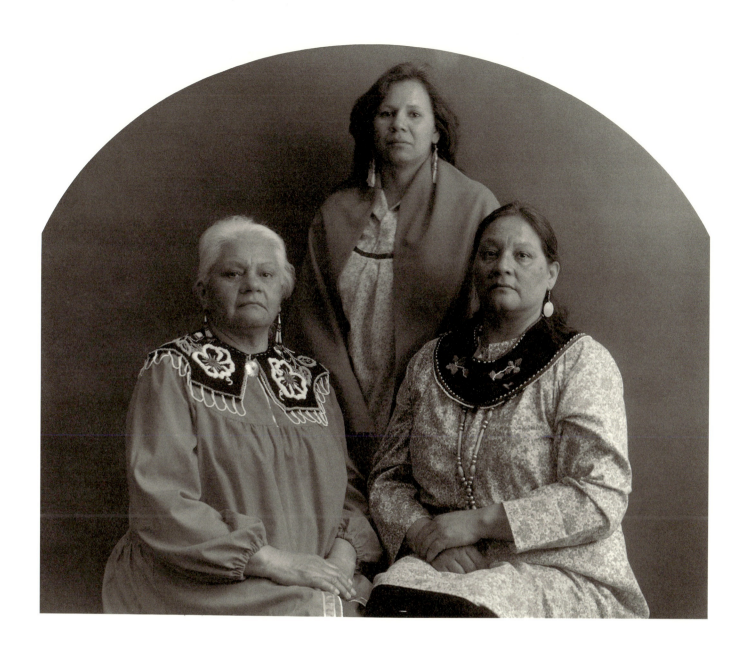

3

CLAN MOTHER AUDREY SHENANDOAH, Keeping Deer Clan
with daughters MIDWIFE JESSICA JEANNE SHENANDOAH and ROCHELLE BROWN, Eel Clan

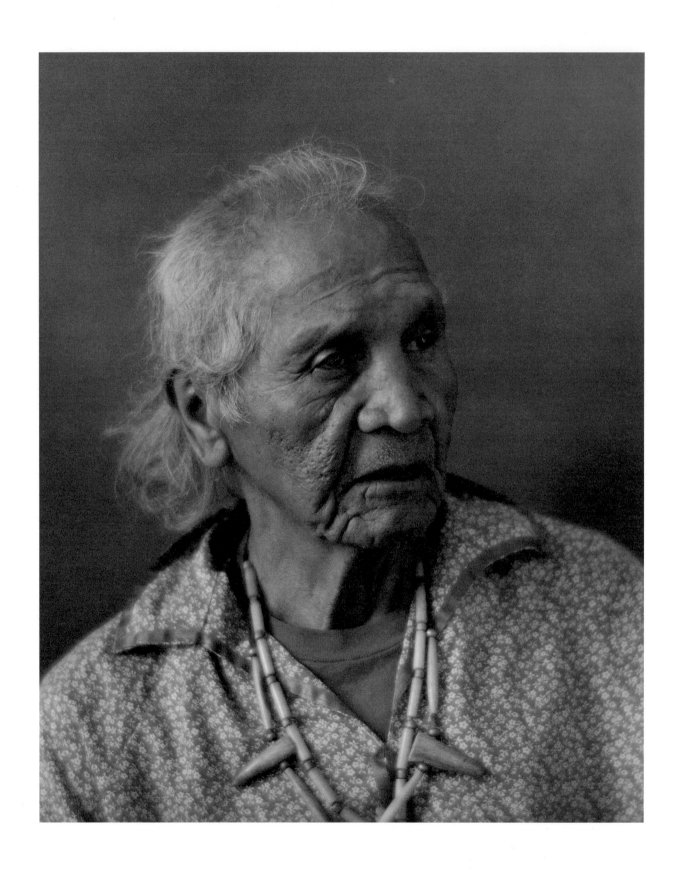

4

CHIEF LEWIS FARMER, Eel Clan

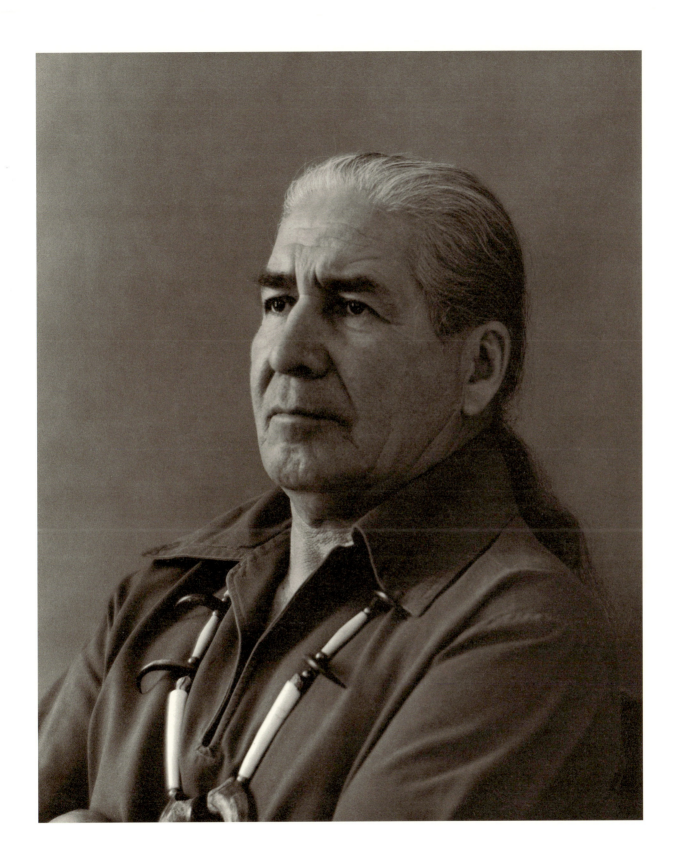

5

JOAGQISHO (Wolf Clan)

FAITHKEEPER TURTLE CLAN, ONONDAGA COUNCIL OF CHIEFS

Oren R. Lyons

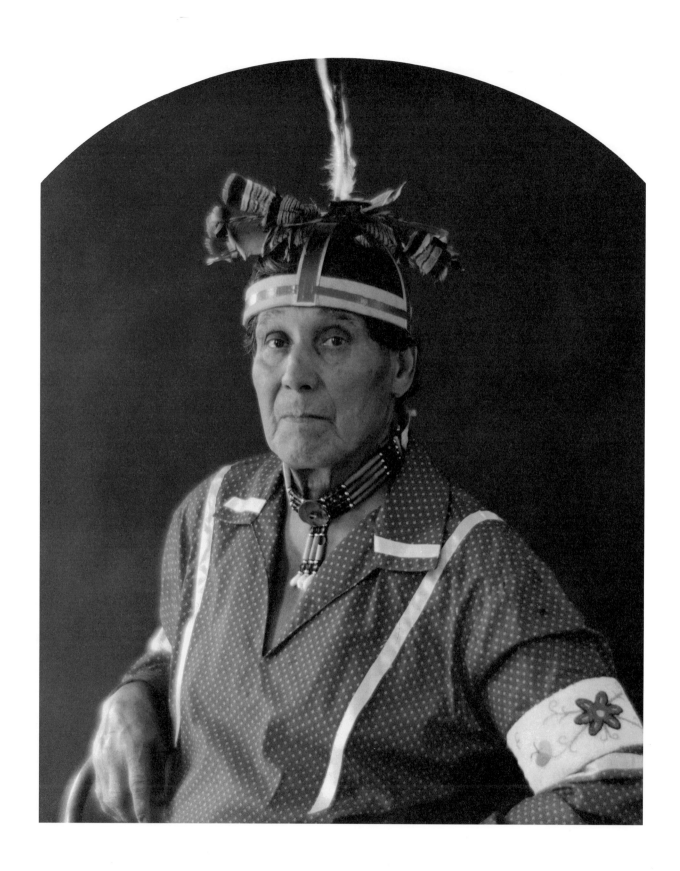

EDWARD E. SHENANDOAH, Eel Clan

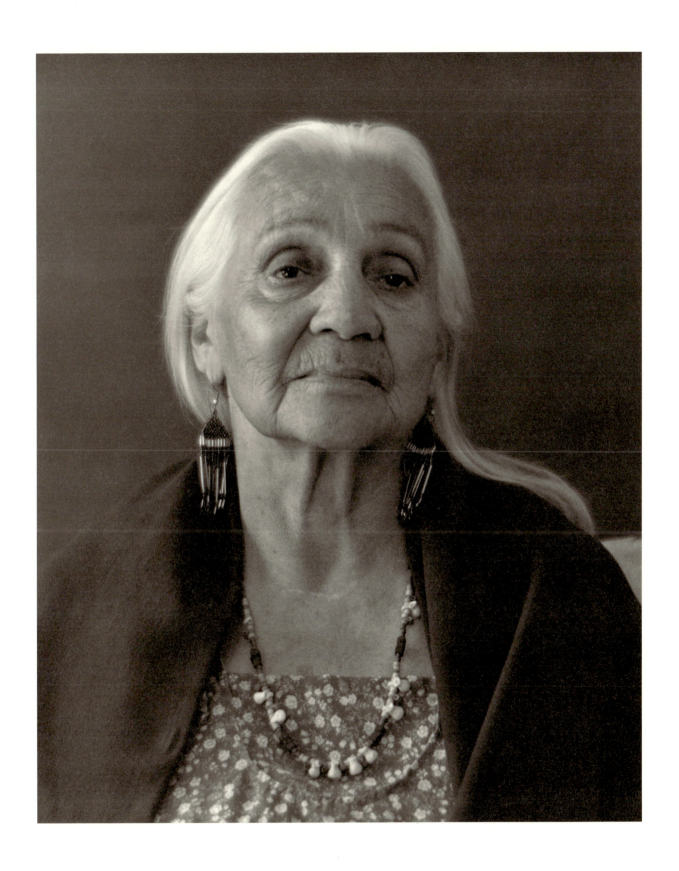

7

CLAN MOTHER DEWASENTA ALICE PAPINEAU, Eel Clan

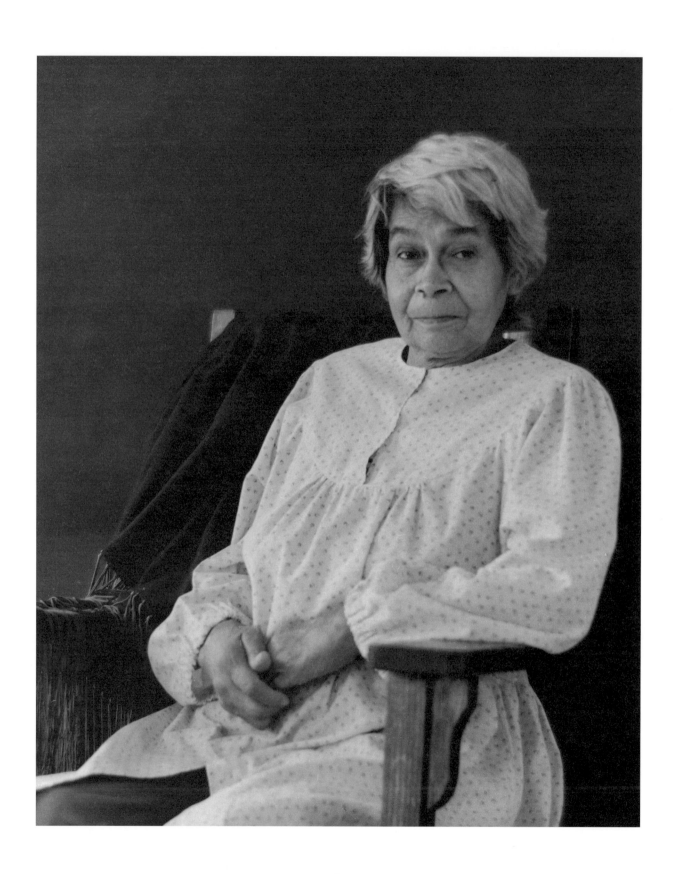

FAITHKEEPER PHOEBE HILL, Eel Clan

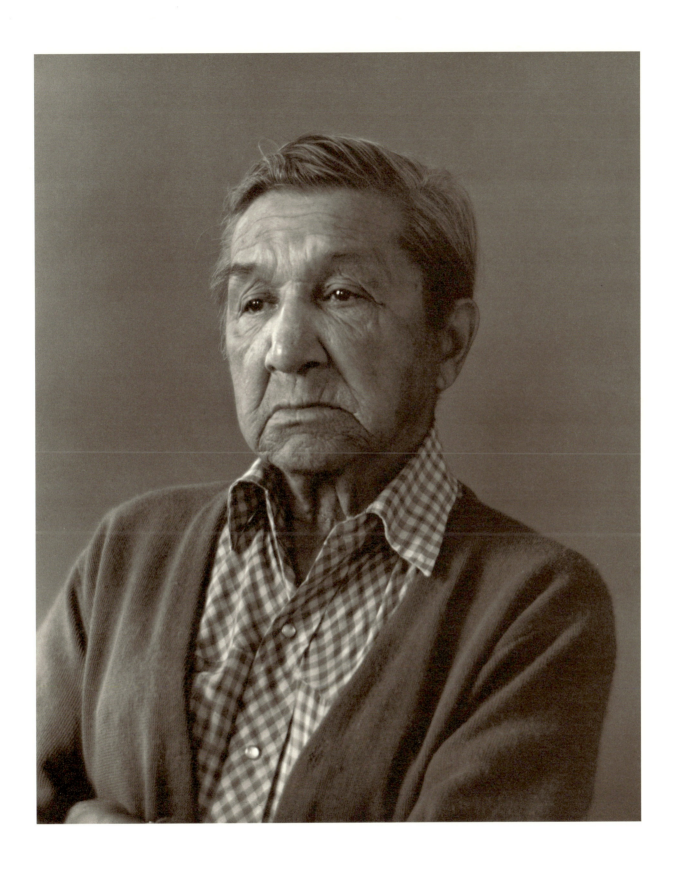

9

EMERSON WATERMAN, Turtle Clan

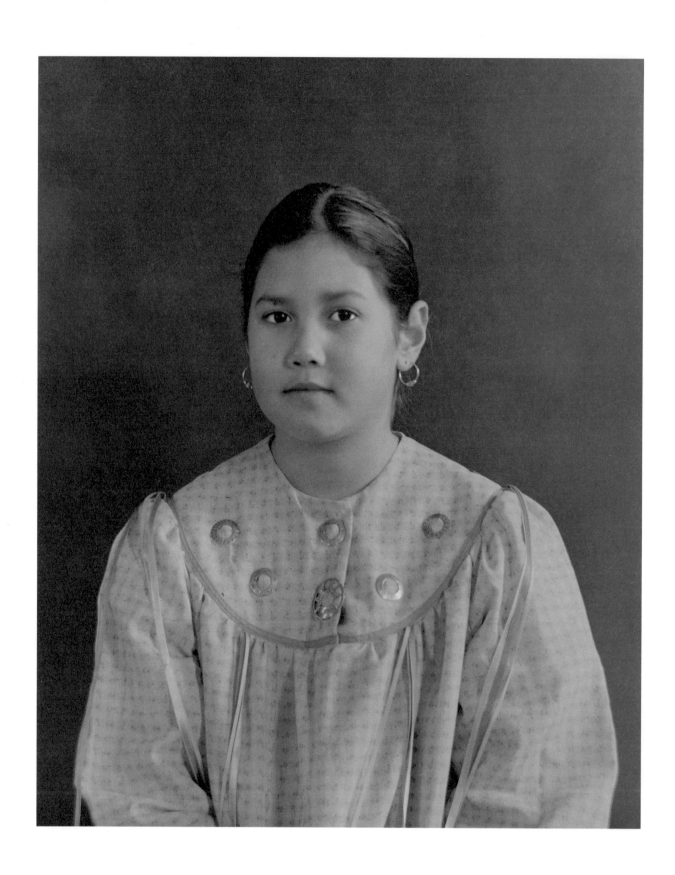

10

JADA MARIE HOPPER, Beaver Clan

Sherri Waterman-Hopper's daughter

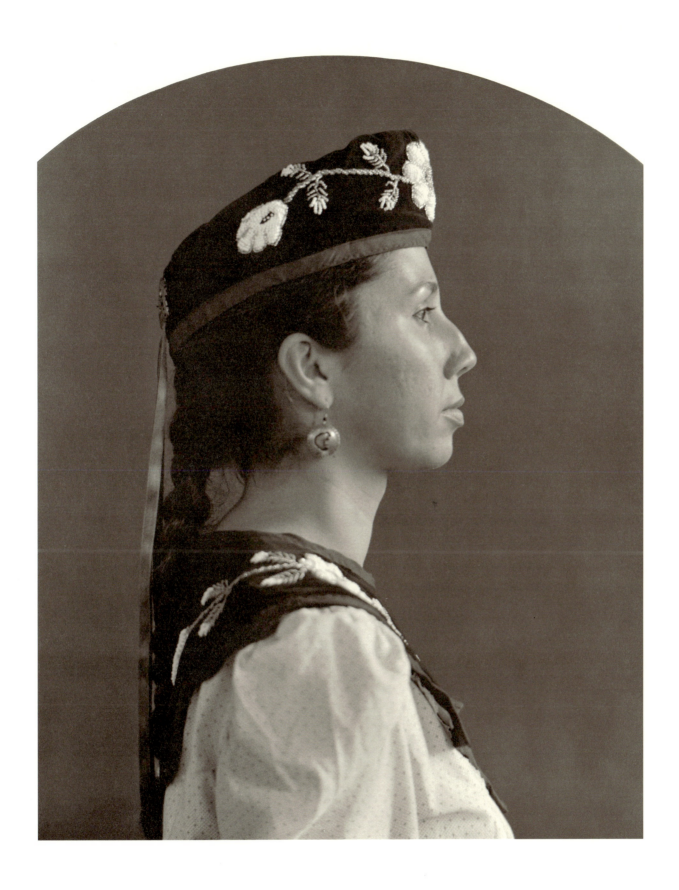

11

SHERRI WATERMAN-HOPPER, Beaver Clan

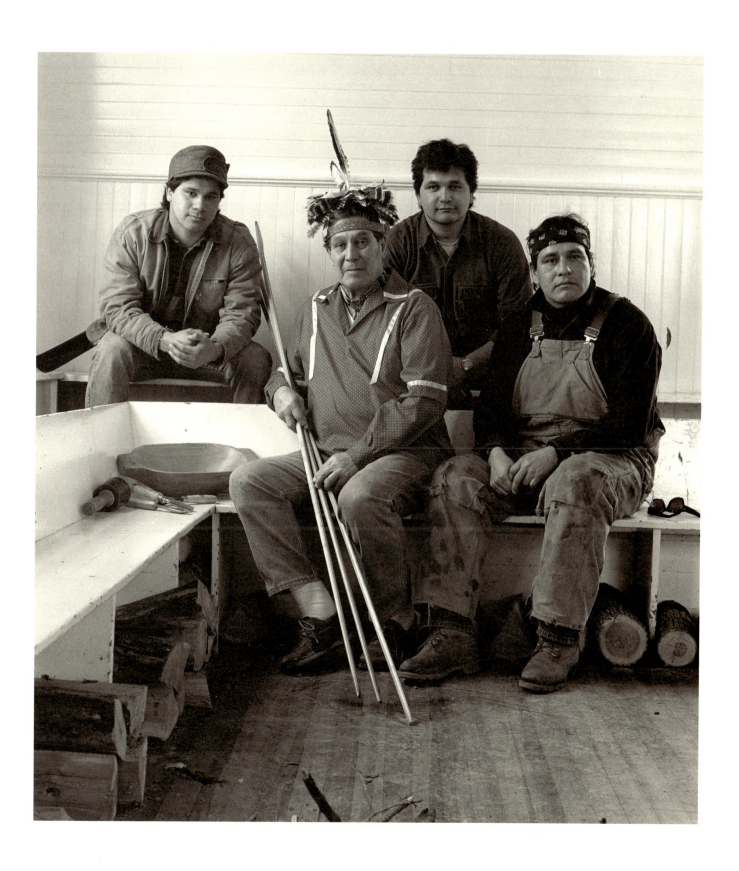

12

EDWARD E. SHENANDOAH, holding snow snakes
with sons ALLEN, ROBERT, and KEITH SHENANDOAH, Eel Clan

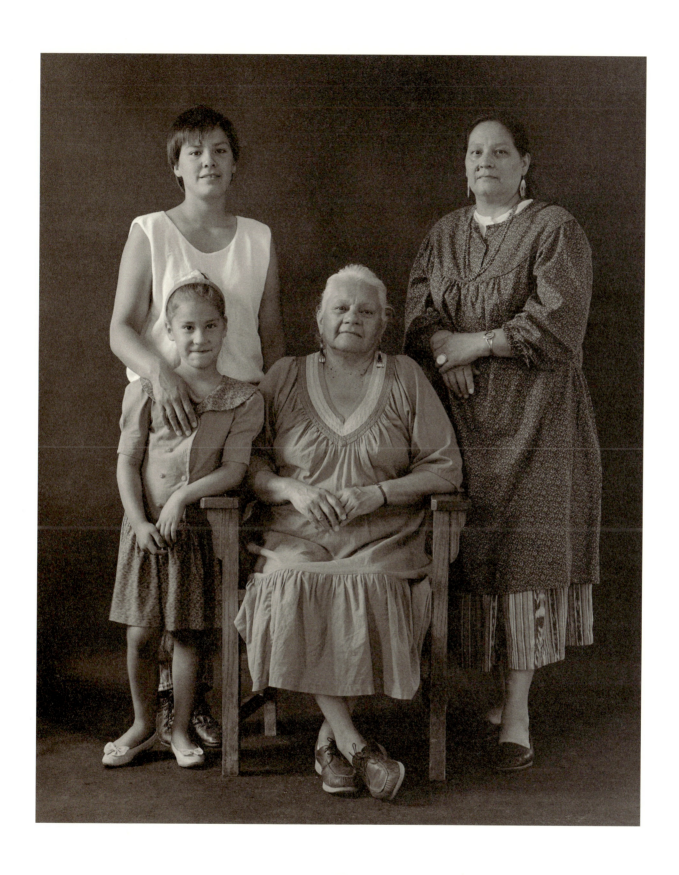

13

CLAN MOTHER AUDREY SHENANDOAH, Keeping Deer Clan
with daughter MIDWIFE JESSICA JEANNE SHENANDOAH, granddaughter VERNA JONES
and great-granddaughter COURTNEY LA ZORE, Eel Clan–Four Generations

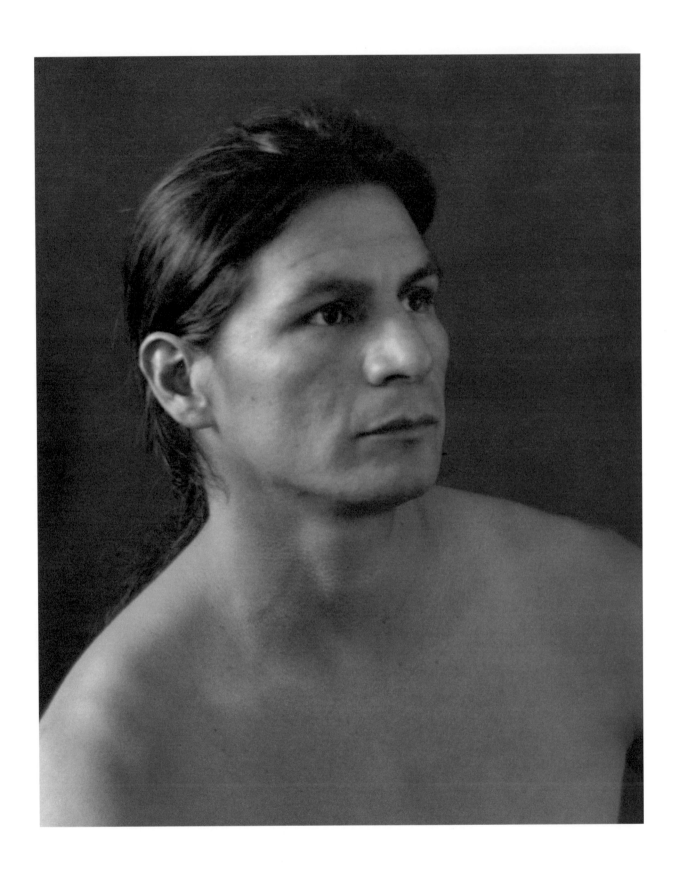

14

TRACY L. SHENANDOAH, ceremonial singer, Eel Clan

Clan Mother Audrey Shenandoah's son

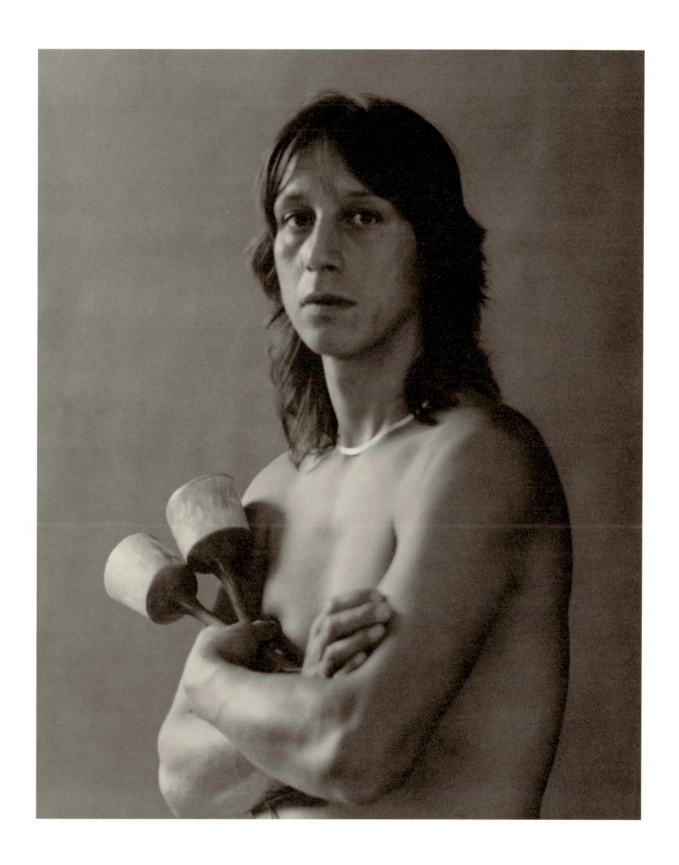

15

KEITH PRINTUP, Eel Clan, holding ceremonial rattles

Midwife Jessica Jeanne Shenandoah's son

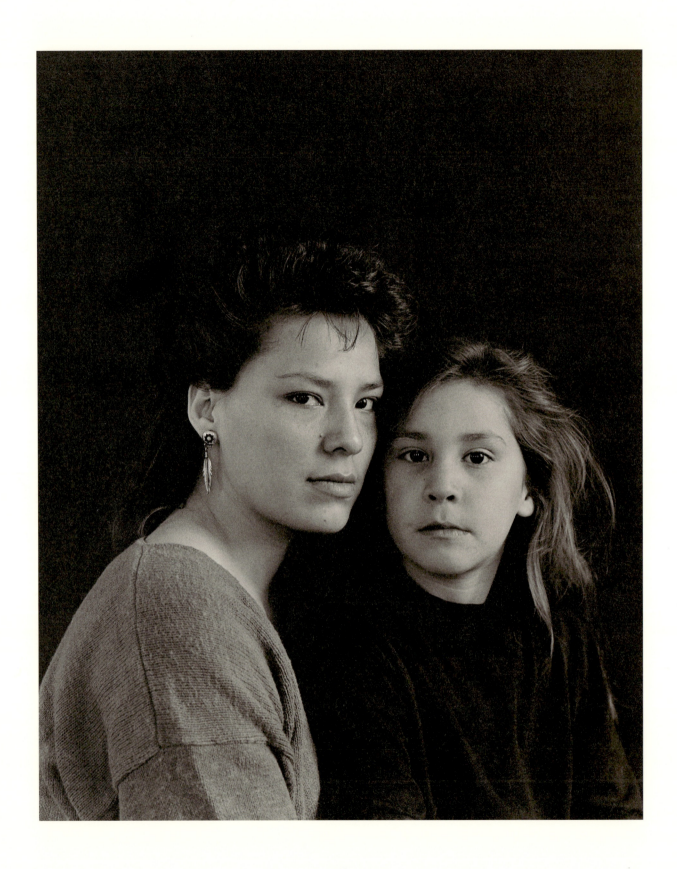

16

VERNA JONES with daughter COURTNEY LA ZORE, Eel Clan

Midwife Jessica Jeanne Shenandoah's daughter and granddaughter

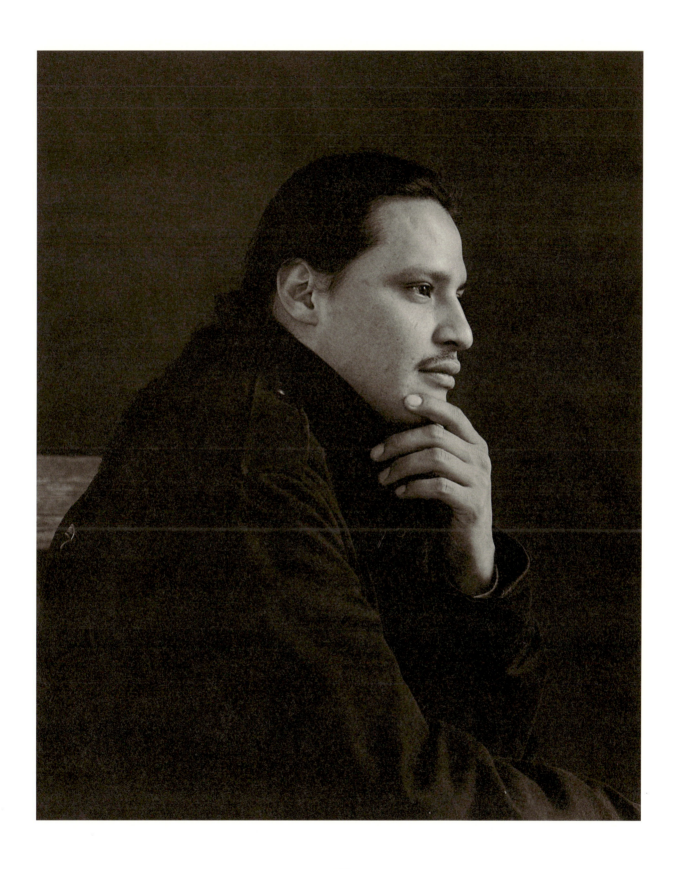

17

ADAM PRINTUP, Eel Clan

Midwife Jessica Jeanne Shenandoah's son

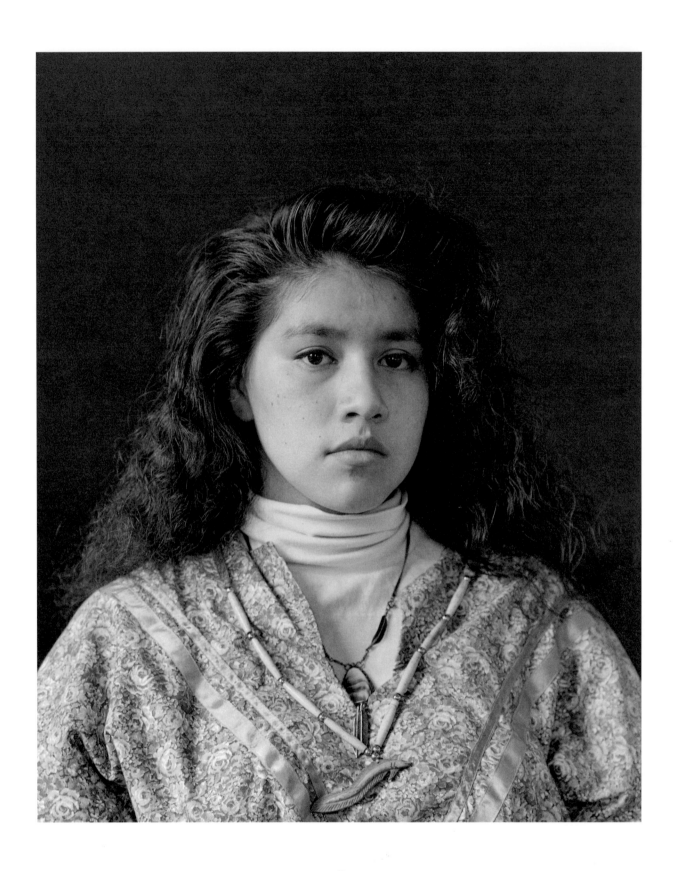

18

SUMMER HONYOUST, Eel Clan

Faithkeeper Mary Honyoust and Charles J. Honyoust's daughter

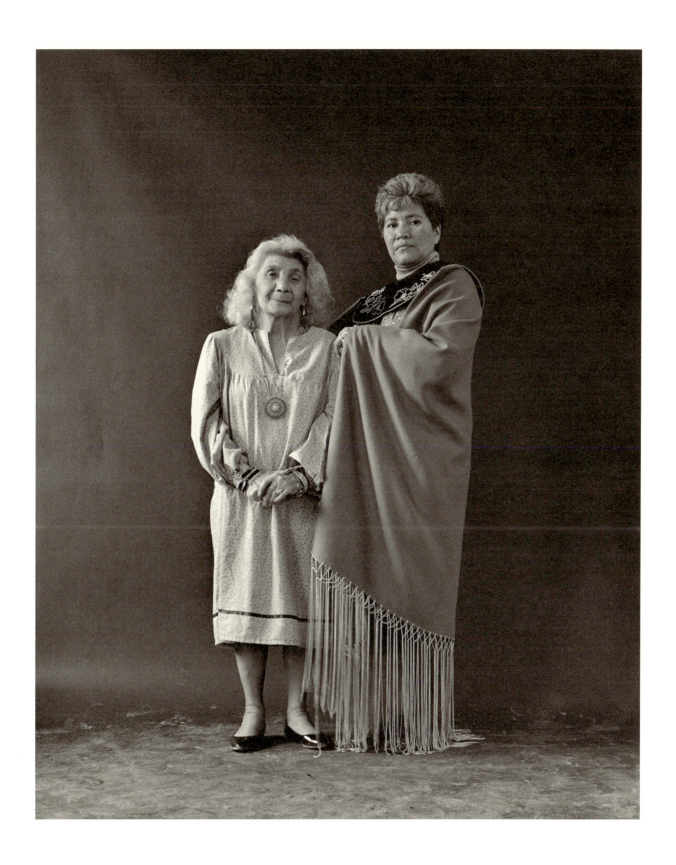

19

FAITHKEEPER MARY HONYOUST with mother MARION GREEN, Eel Clan

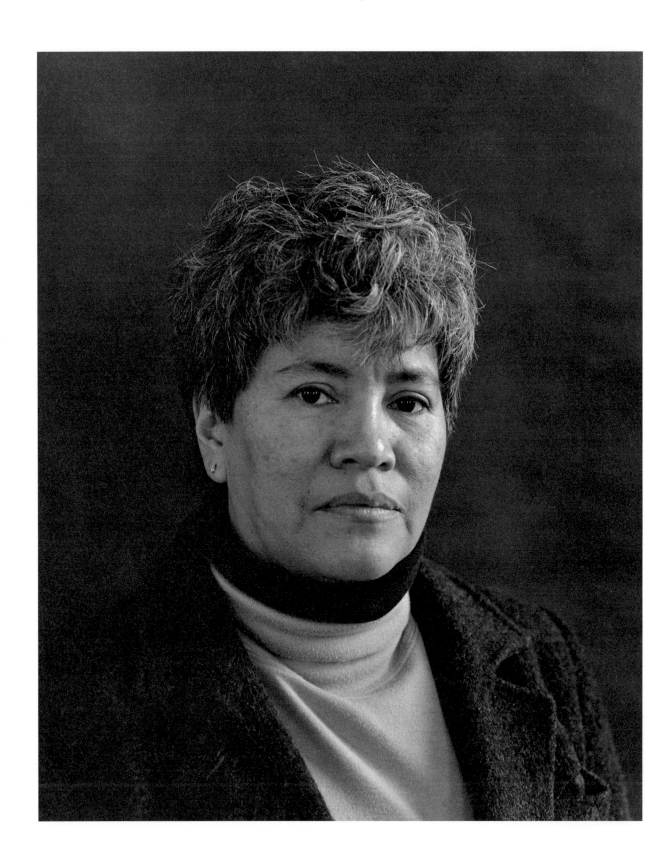

20

FAITHKEEPER MARY HONYOUST, Eel Clan

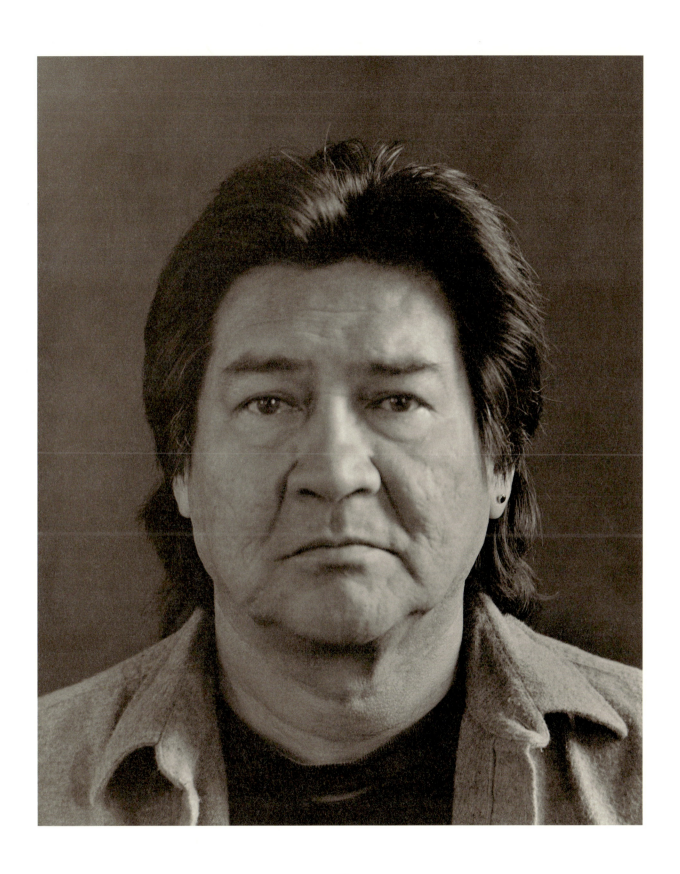

21

CHARLES J. HONYOUST, Wolf Clan

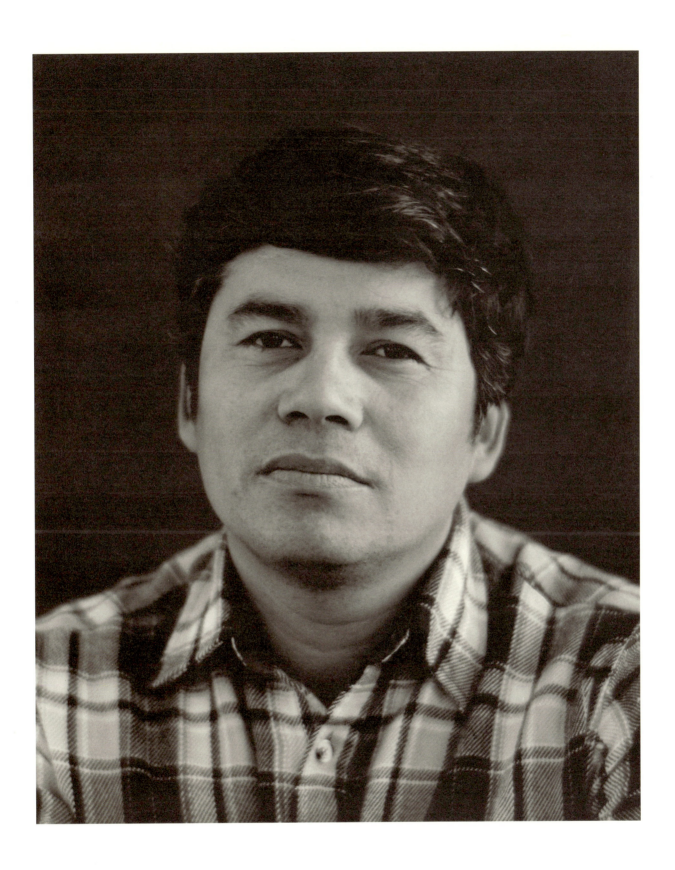

22

CHIEF ALSON GIBSON, Wolf Clan

Chief Ambrose Gibson's son

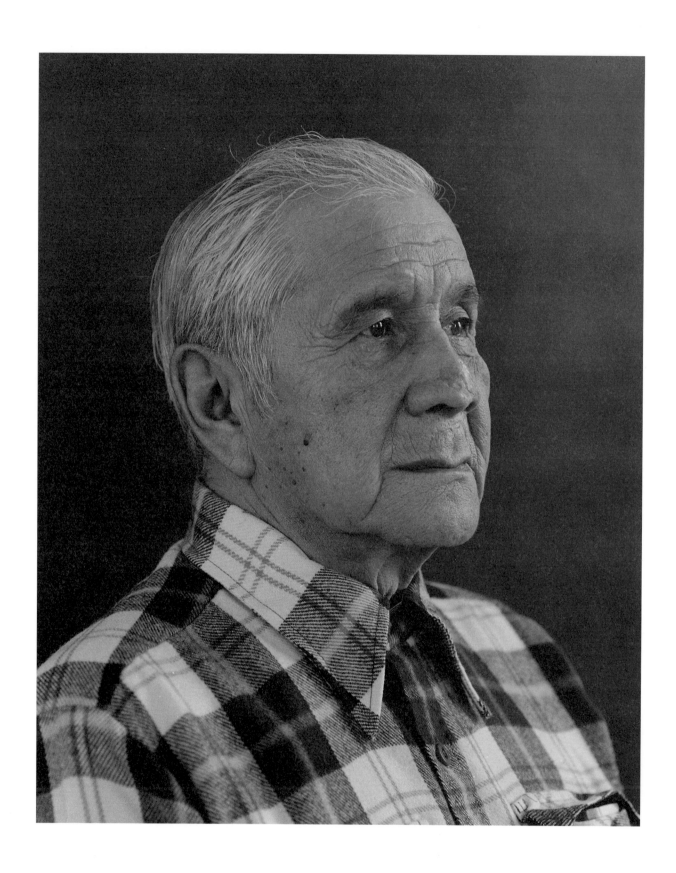

CHIEF AMBROSE GIBSON, Eel Clan

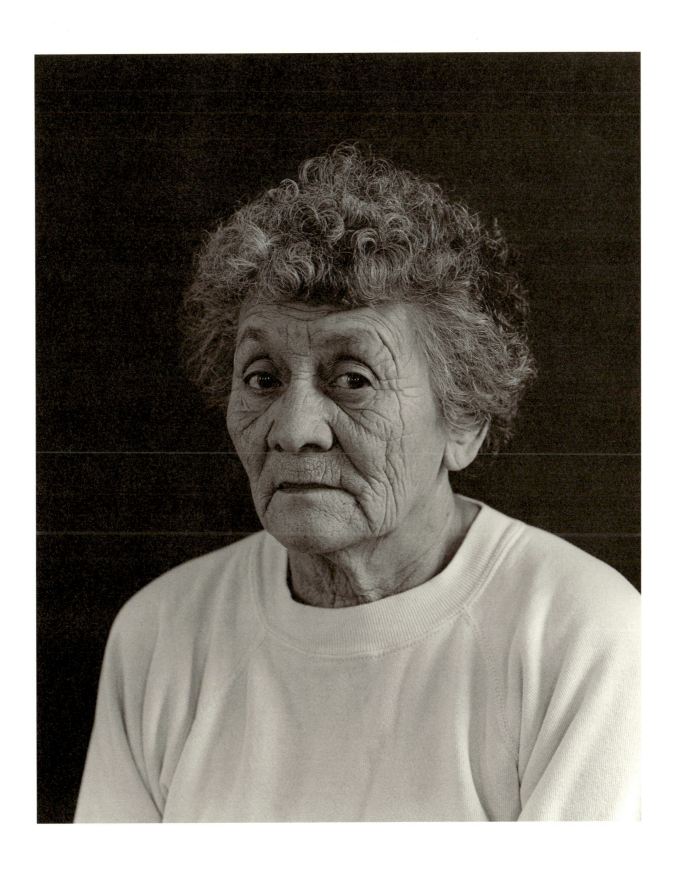

24

TERESA GIBSON, Wolf Clan

Chief Ambrose Gibson's wife

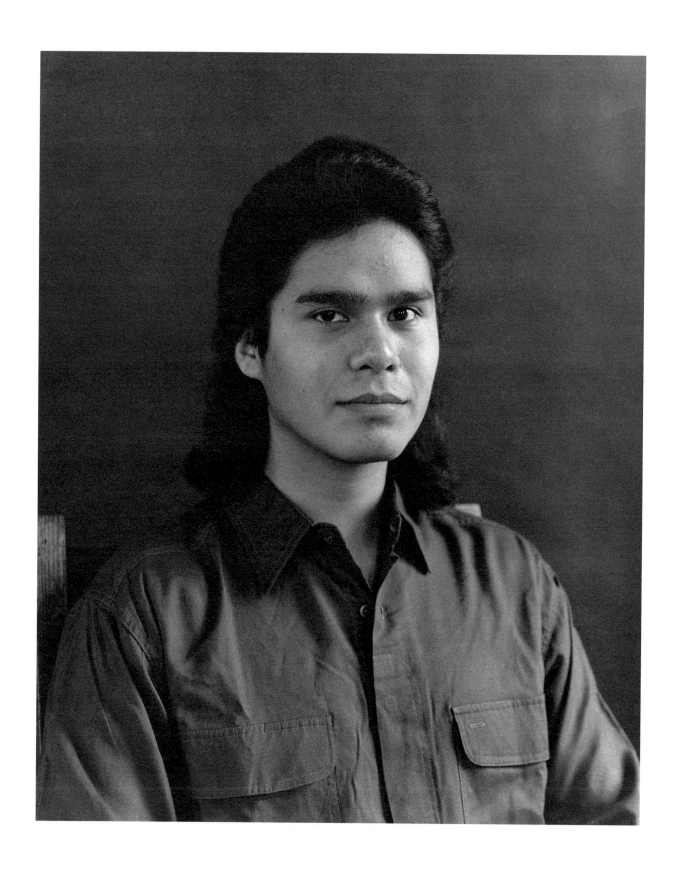

25

ALSON JOHN GIBSON, Cayuga Wolf Clan

Chief Alson Gibson's son

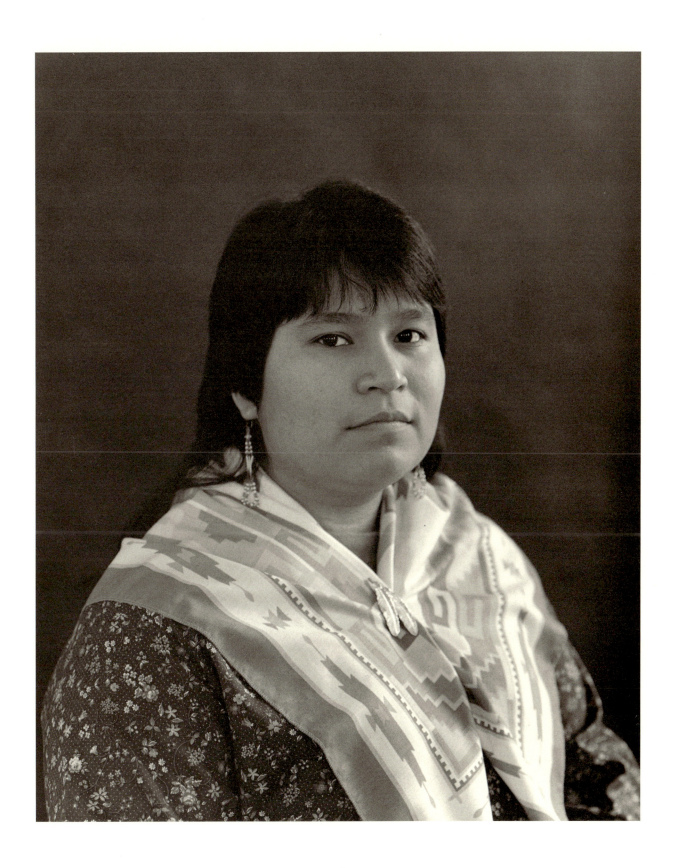

26

MISSY GIBSON, Cayuga Wolf Clan

Chief Alson Gibson's daughter

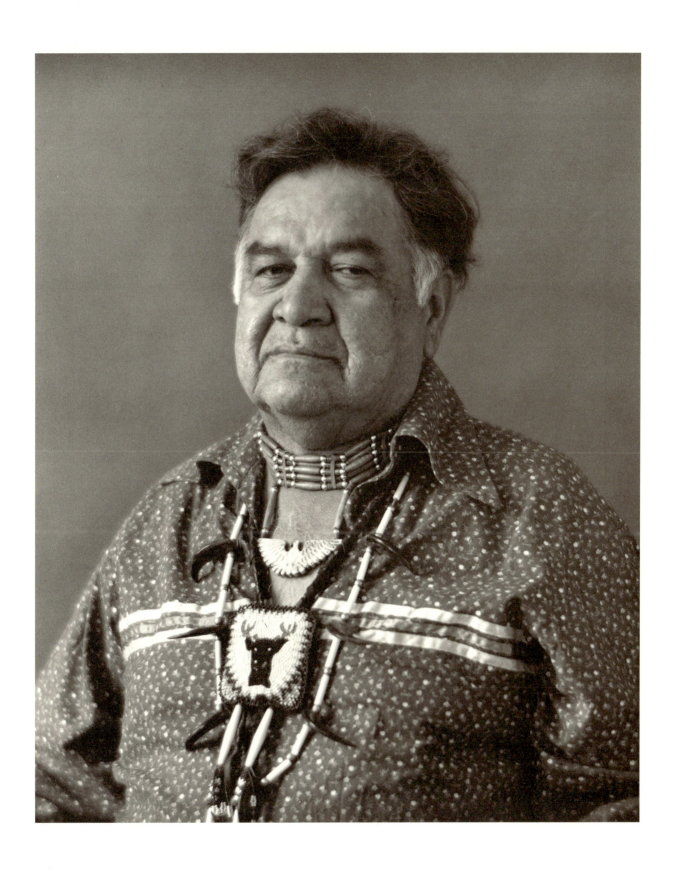

CHIEF NORMAN POWLESS, Deer Clan

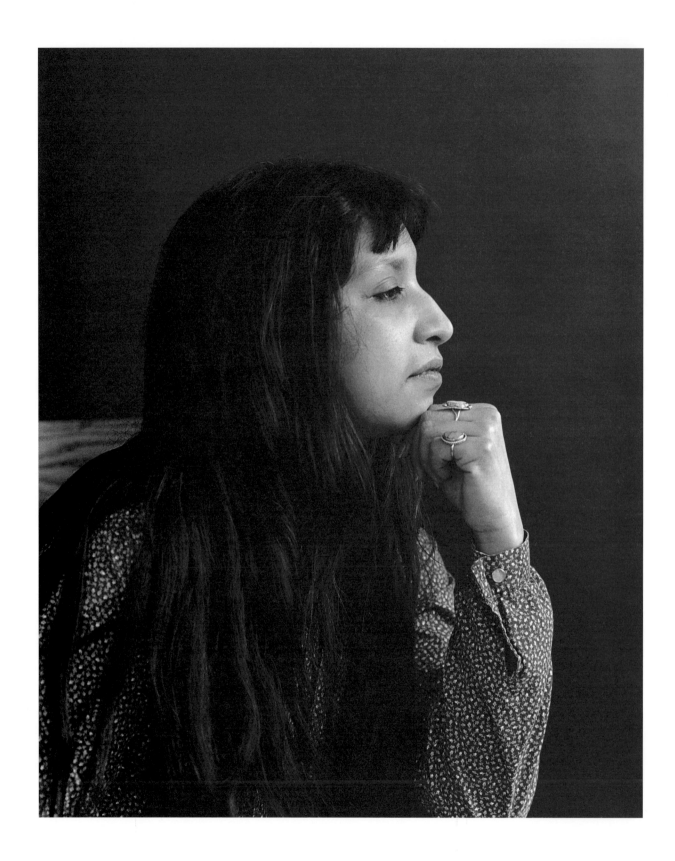

MAXINE CROUSE, Eel Clan

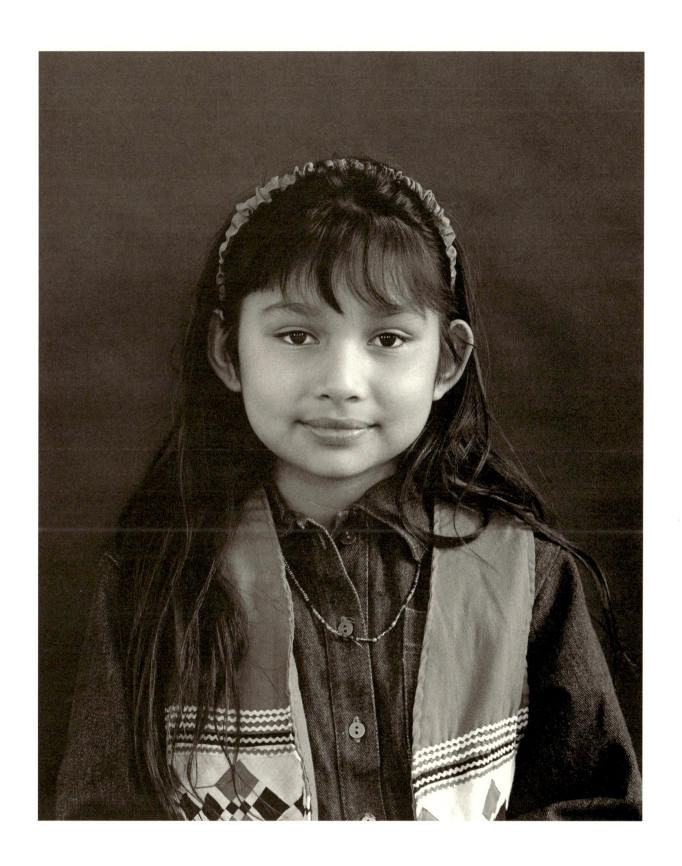

29

ELIZABETH ROCKWELL, Eel Clan

Maxine Crouse's daughter

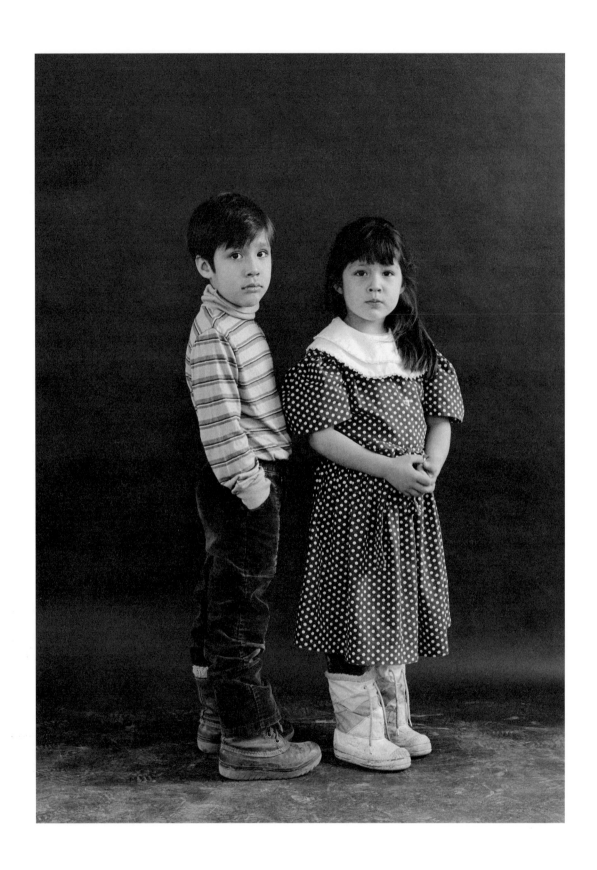

30

SPENCER LYONS with sister MARCIA LYONS, Hawk Clan

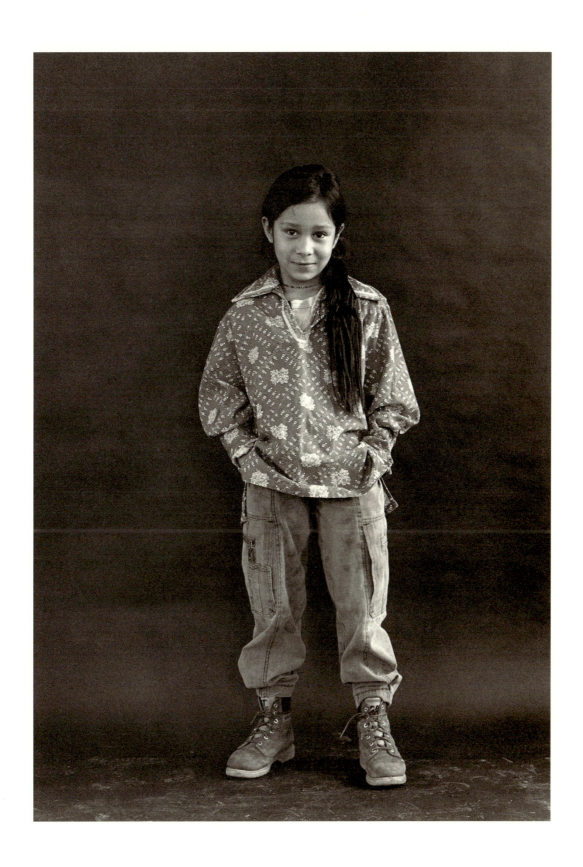

31

JOSHUA ROCKWELL, Eel Clan

Maxine Crouse's son

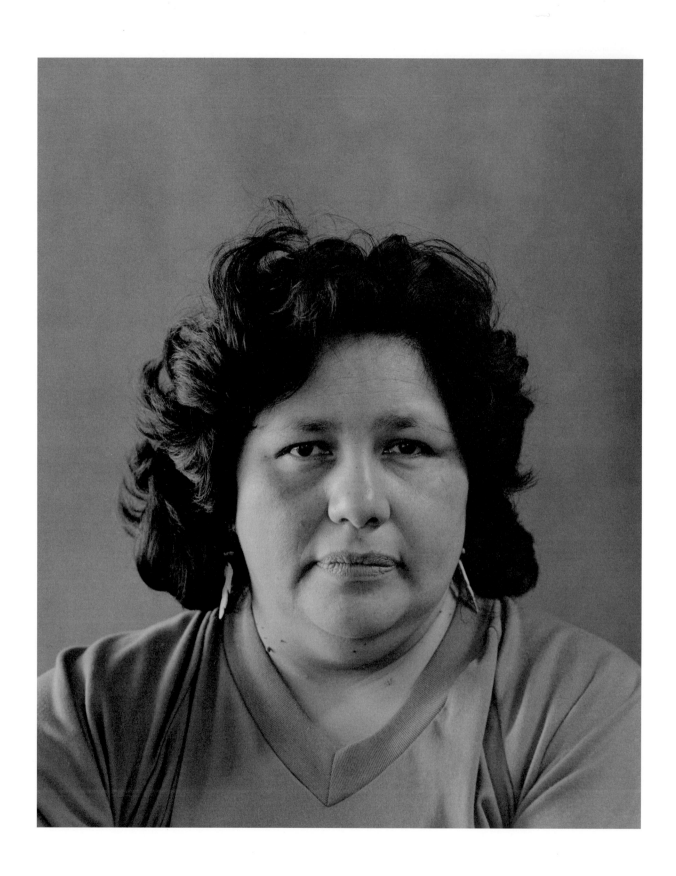

VICTORIA ISAAC, Eel Clan

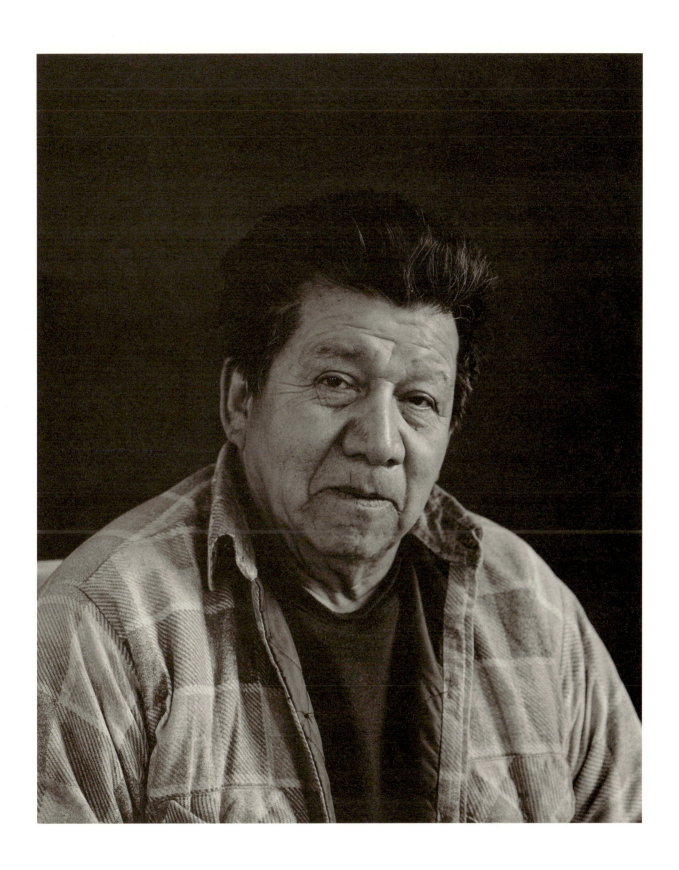

33

LESLIE POWLESS, Eel Clan

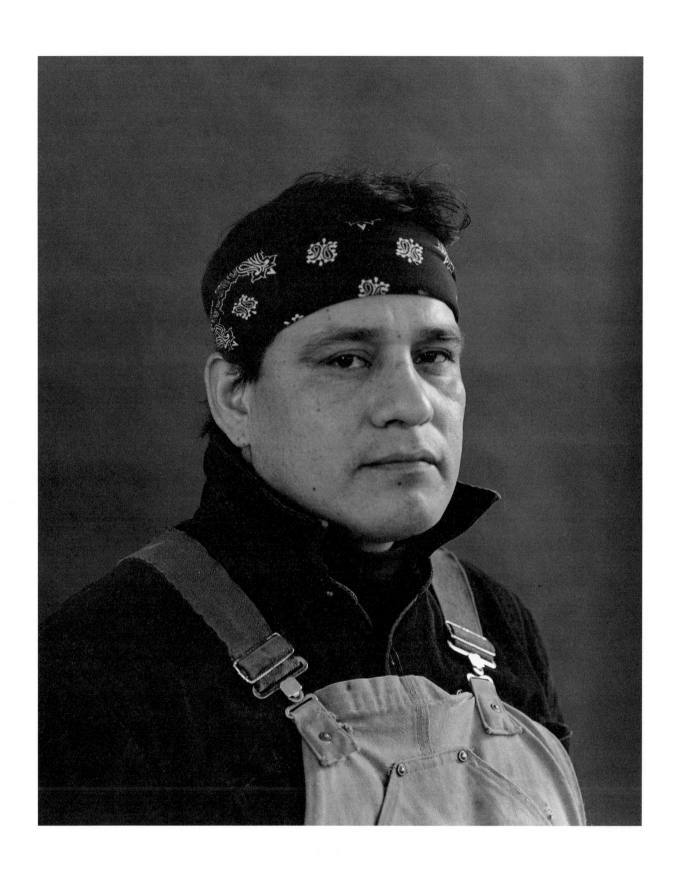

34

KEITH (Hiwhasa) SHENANDOAH, Eel Clan

Clan Mother Audrey Shenandoah's son

Sunny, Cassie, Lynn, and Helen Shenandoah's father

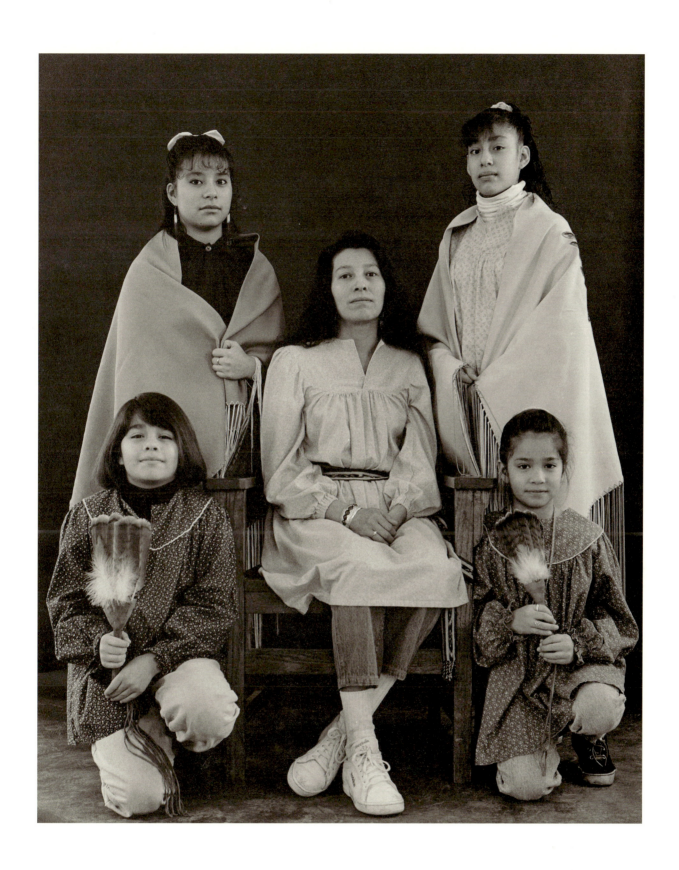

35

REGINA A. JONES with daughters

SUNNY, CASSIE, LYNN, and HELEN SHENANDOAH, Oneida Turtle Clan

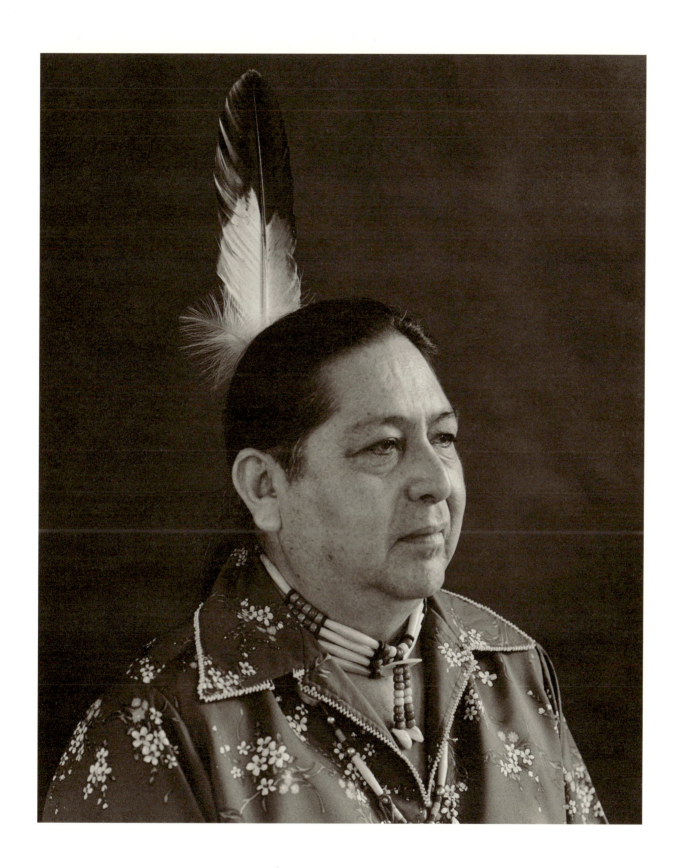

36

CHIEF IRVING POWLESS JR., Wolf Clan

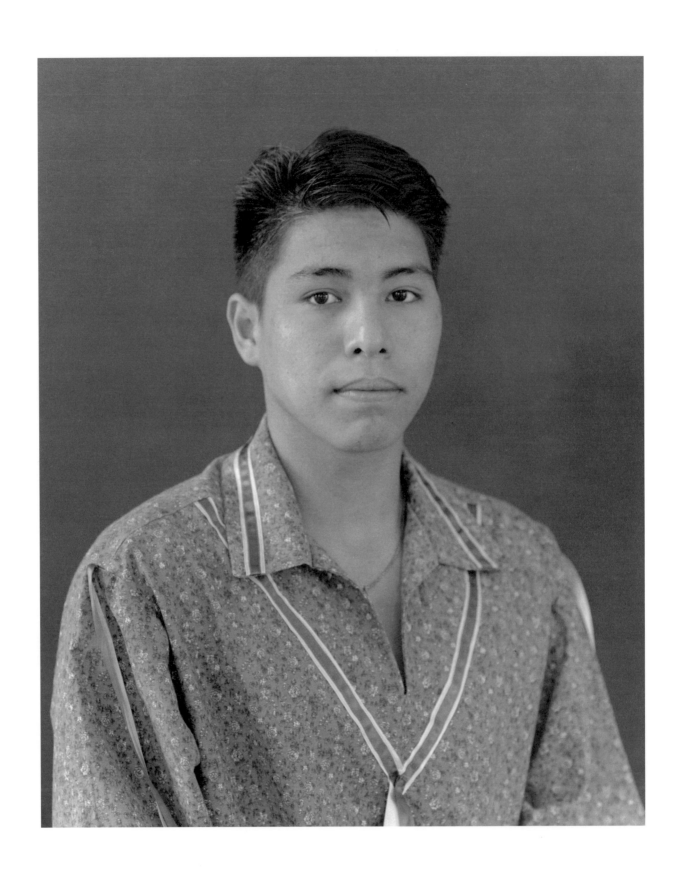

37

NEAL POWLESS, Eel Clan

Chief Irving Powless Jr.'s son

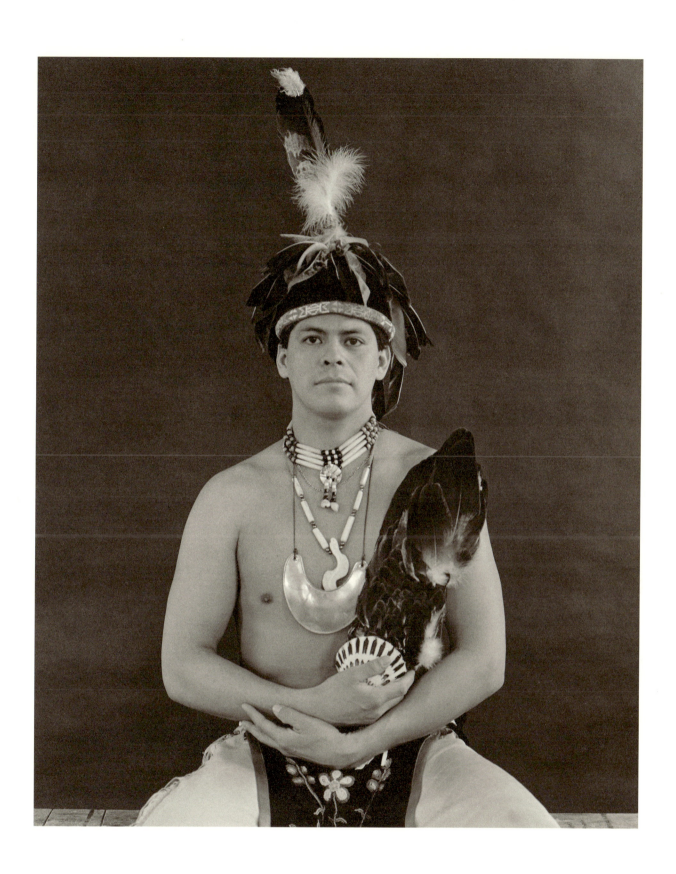

38

BARRY POWLESS, Eel Clan

Chief Irving Powless Jr.'s son

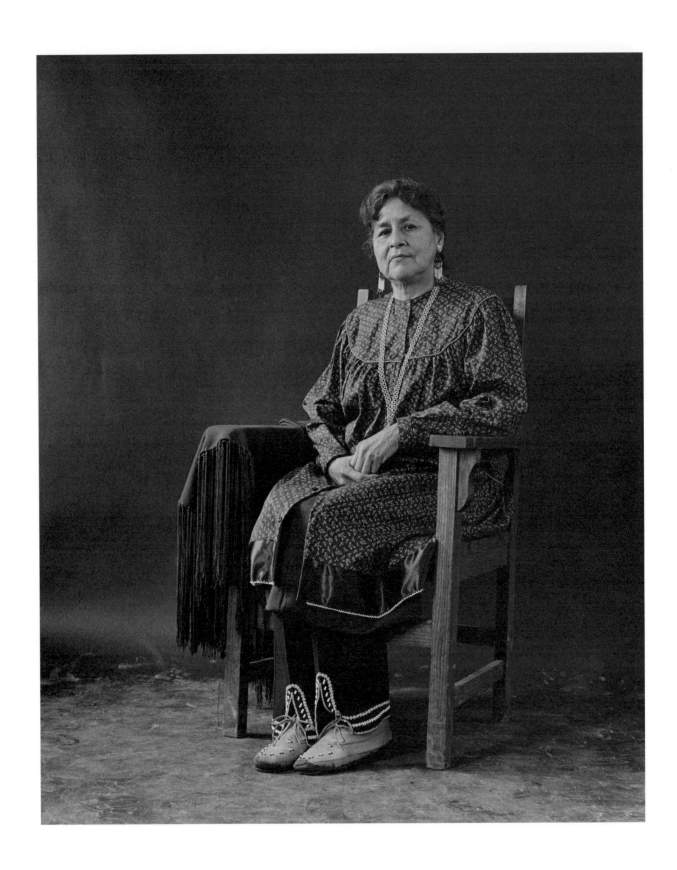

EULALIE MOSES, Tuscarora Beaver Clan

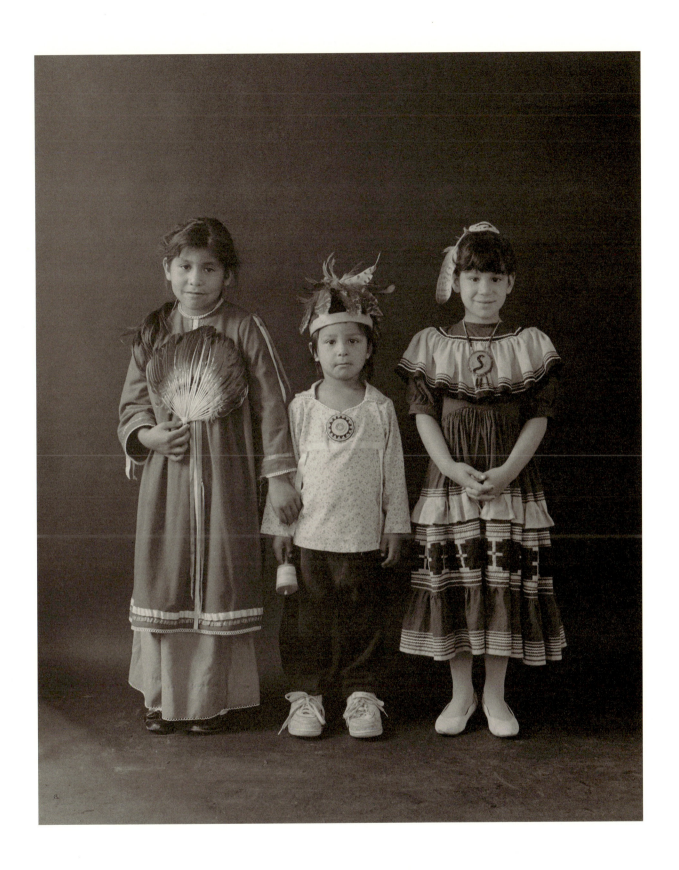

40

ALLISON and ARON CROUSE, Tuscarora Beaver Clan

with cousin SAMANTHA MOSES, Eel Clan

Eulalie Moses' grandchildren

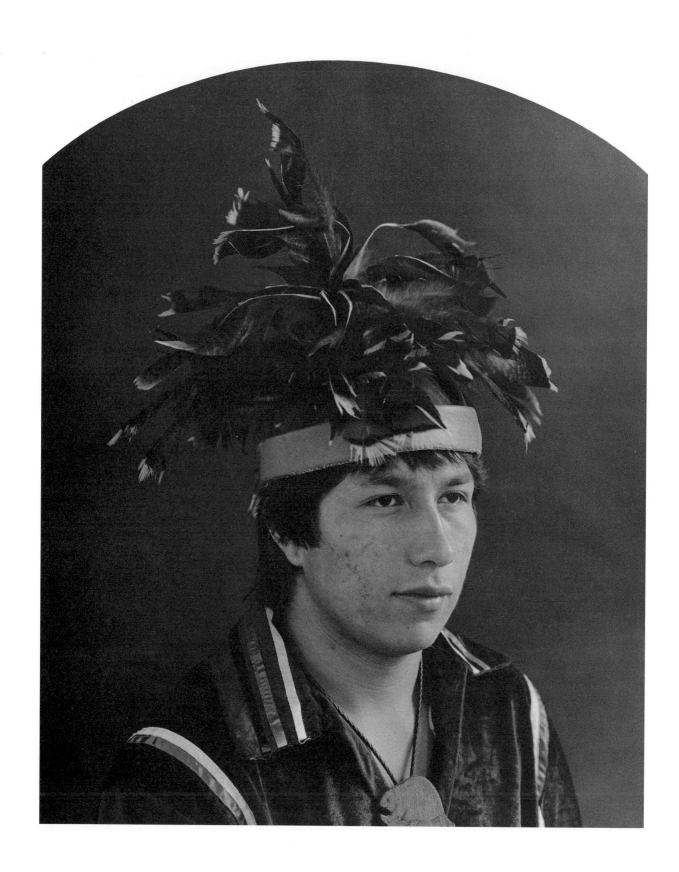

41

BOO CROUSE (So Hat Dis), Tuscarora Beaver Clan

Eulalie Moses' son

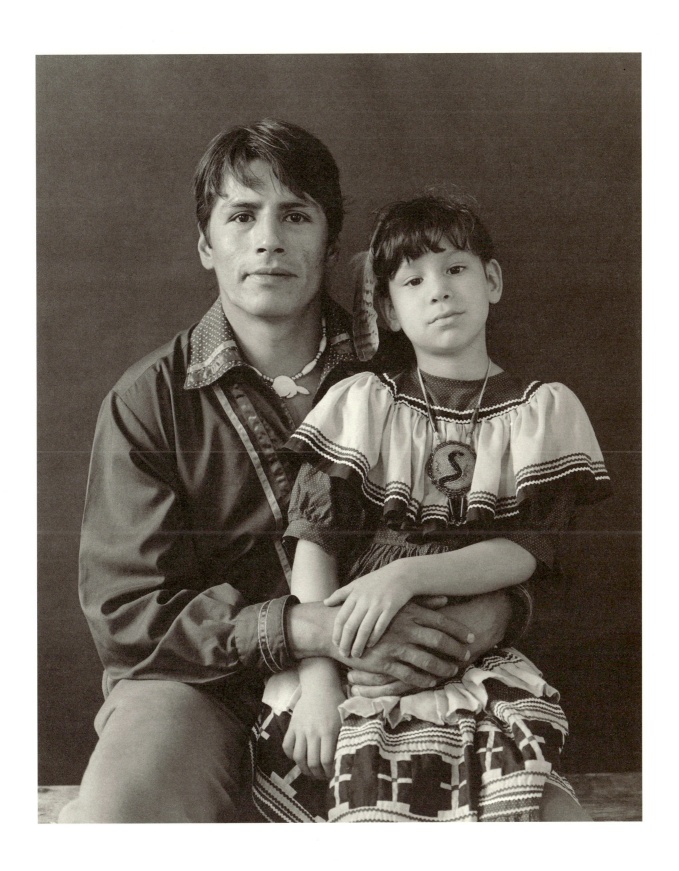

42

ROGER MOSES, Tuscarora Beaver Clan

with daughter SAMANTHA MOSES, Eel Clan

Eulalie Moses' son and granddaughter

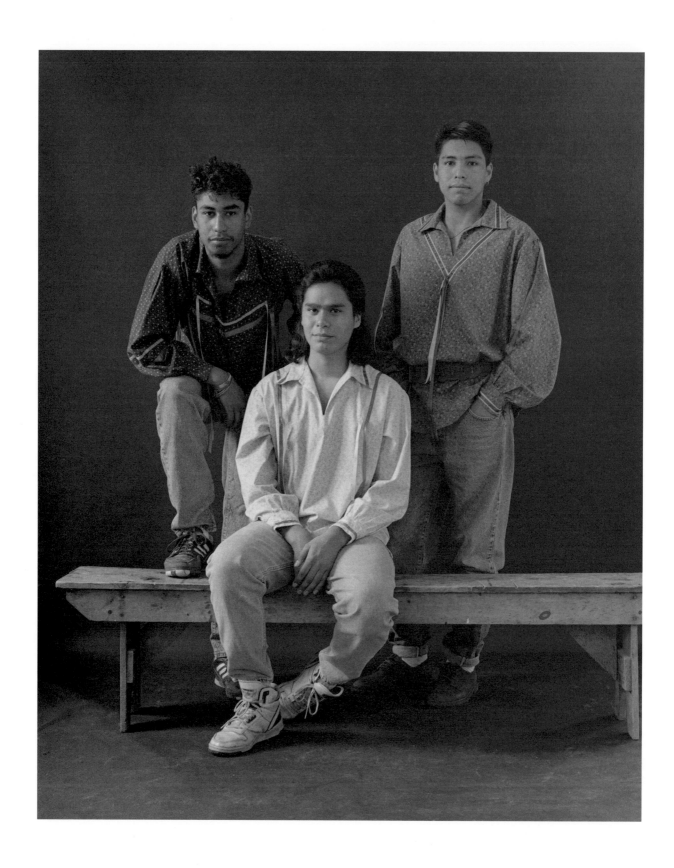

43

ALSON JOHN GIBSON, Cayuga Wolf Clan, WEWOKA SHENANDOAH, Eel Clan, and NEAL POWLESS, Eel Clan

June 1992 High School Graduates

Sons of Chief Alson Gibson and Chief Irving Powless Jr. and grandson of Clan Mother Audrey Shenandoah

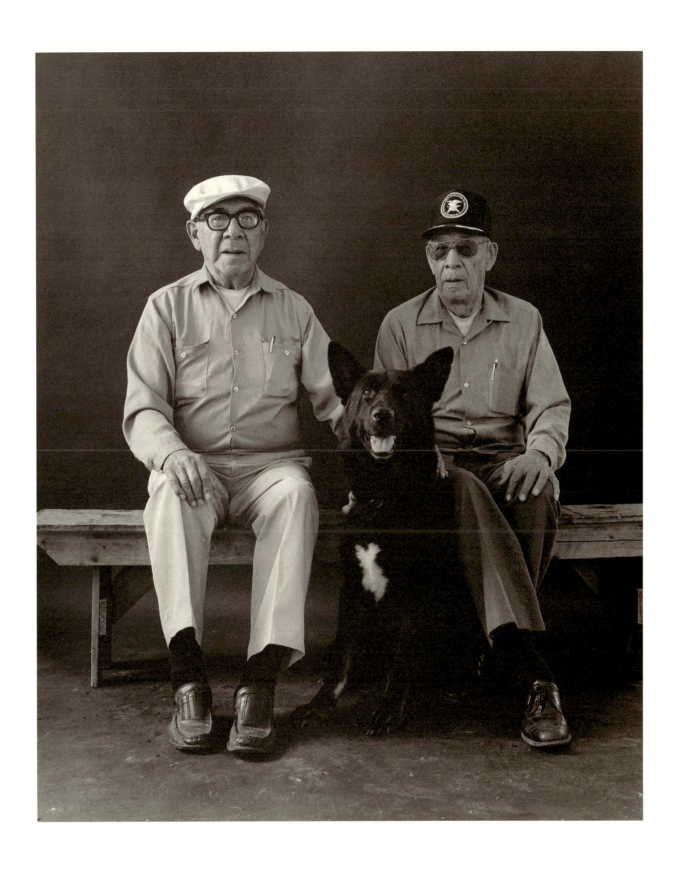

44

DAVID HONYOUST, Eel Clan, and LEON STOUT, Eel Clan

with Okwai

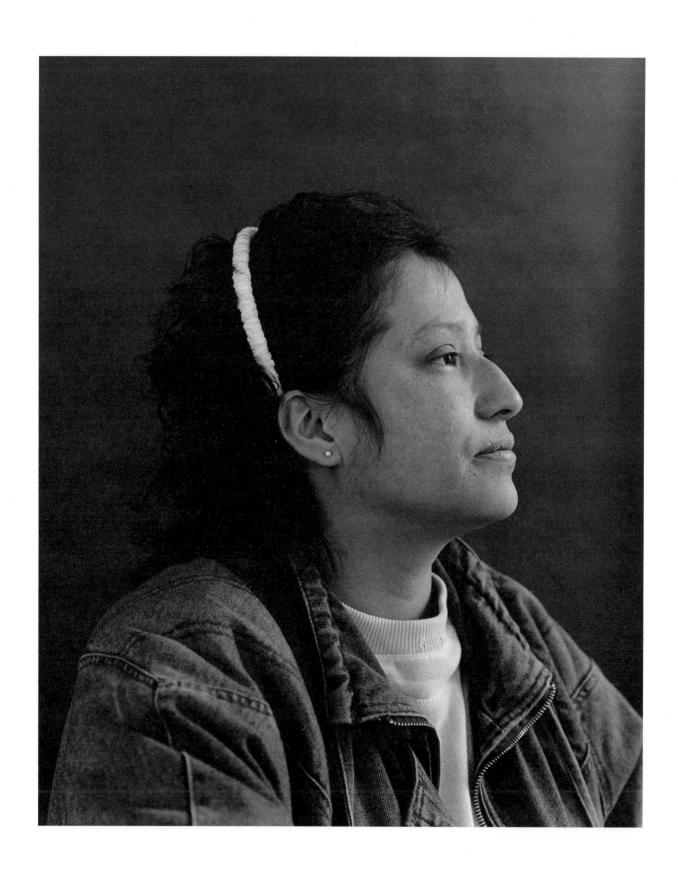

ALMA A. PRINTUP, Turtle Clan

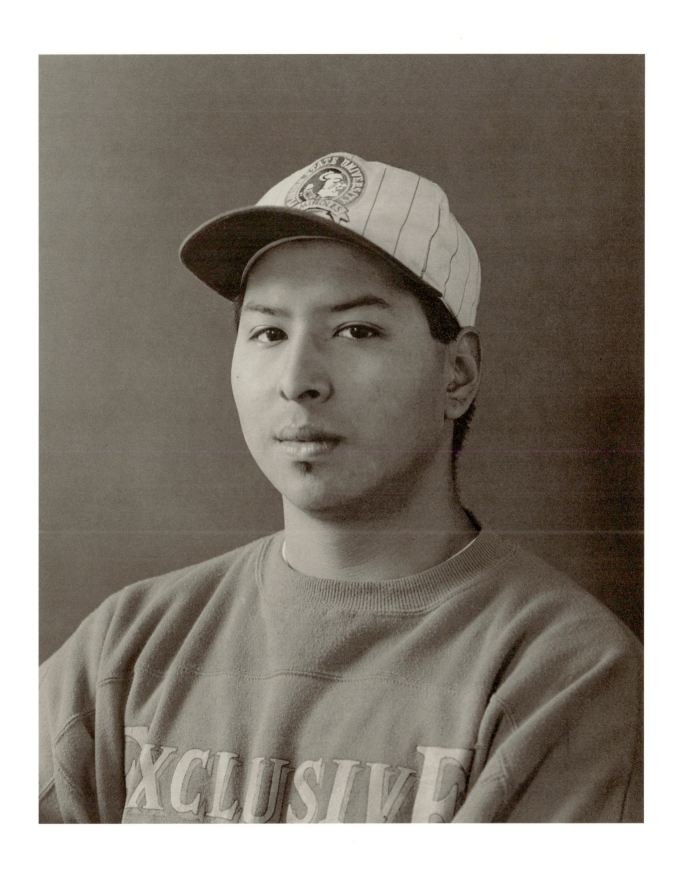

IRA OSCIOLA JOHNSON, Wolf Clan

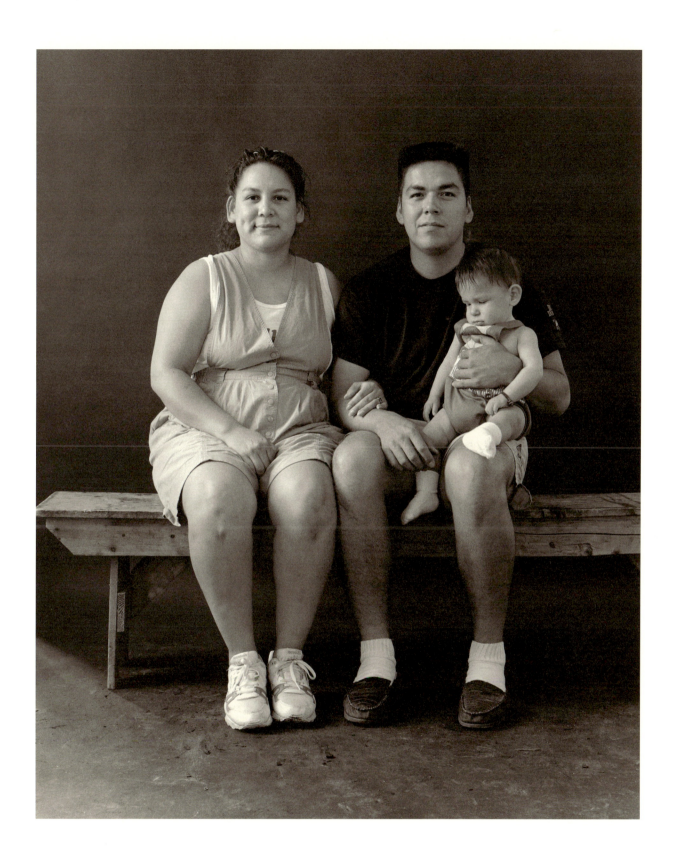

47

PEGGY STEEPROCK, Bear Clan, and JULIAN STEEPROCK JR., Eel Clan
with son JORDAN STEEPROCK, Bear Clan

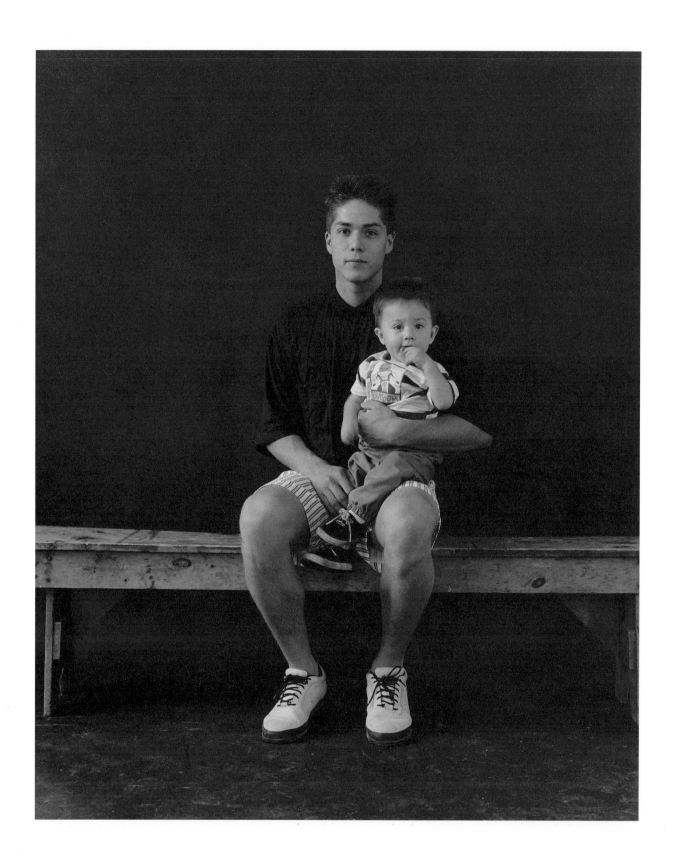

48

KINGSLEY D. LYONS JR., Eel Clan

with son DEAN ADDISON LYONS, Turtle Clan

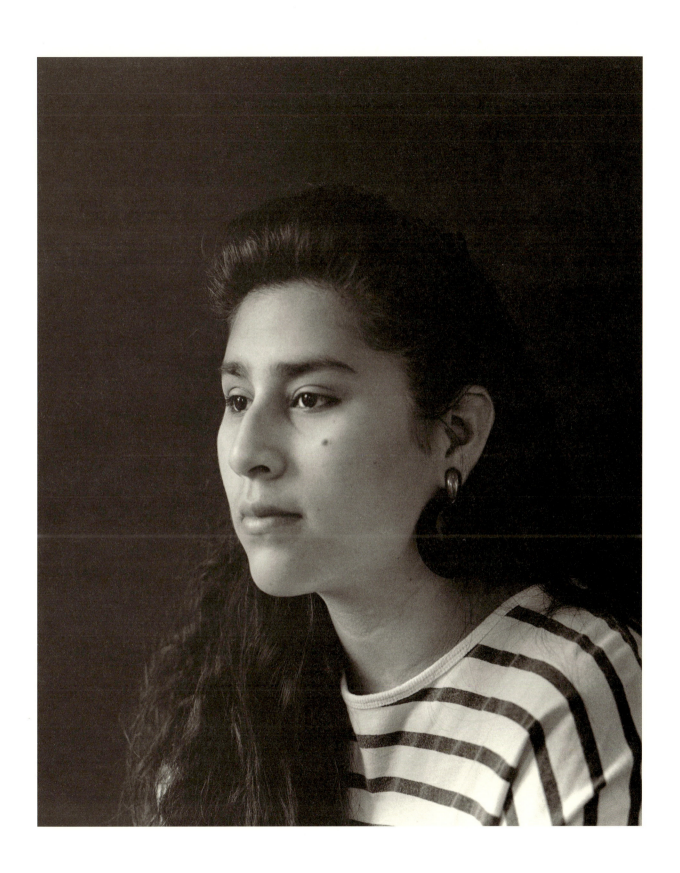

49

JEANNETTE LOWE, Turtle Clan

Dean Addison Lyons' mother

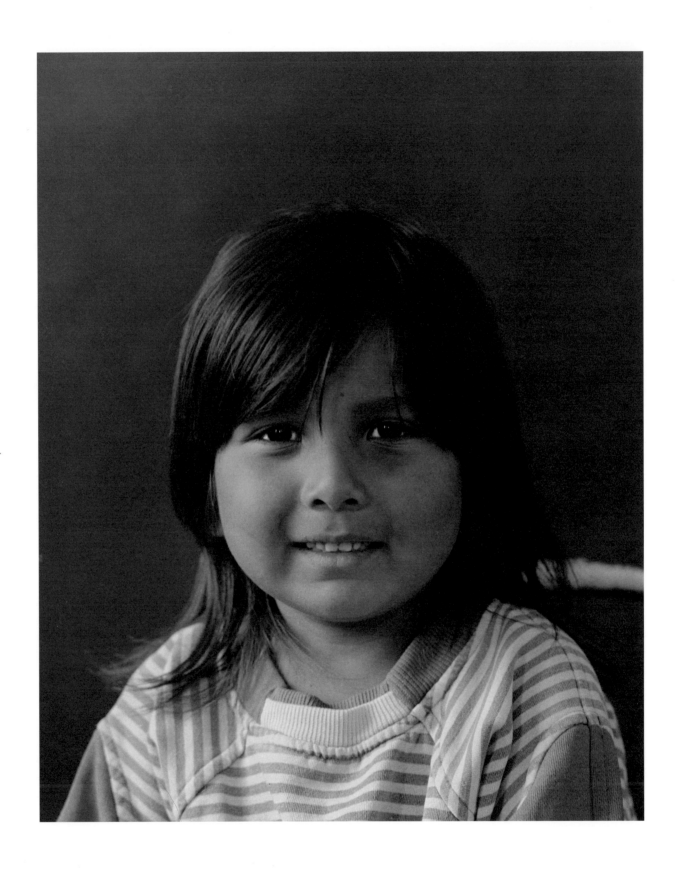

50

PAUL ELM, Beaver Clan

Lloyd M. Elm Jr.'s son

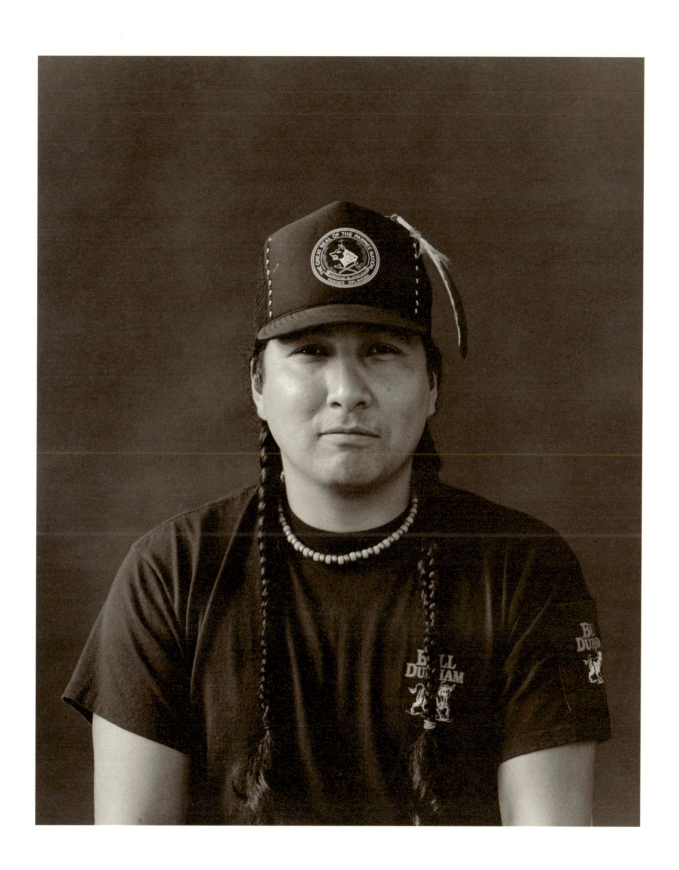

51

LLOYD M. ELM JR., Antelope Clan

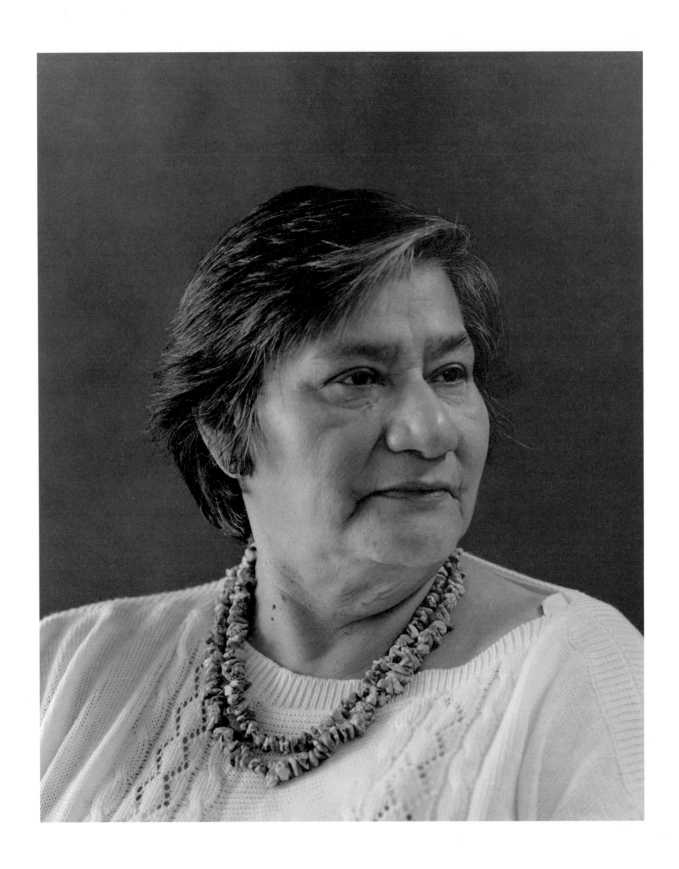

52

DORIS LEWIS, Eel Clan

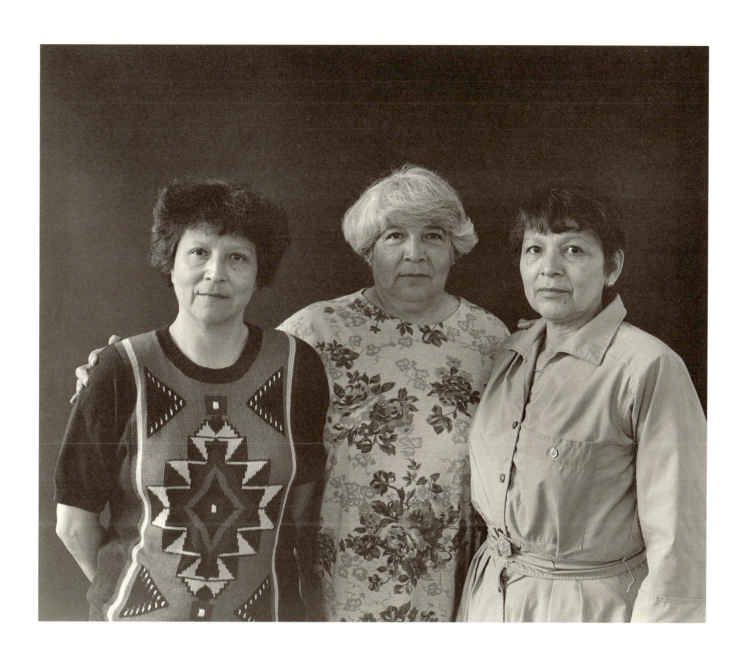

53

ESTHER SULLIVAN, DALE SOLOMON, and ROSETTA MC CLAIRY, Eel Clan, sisters

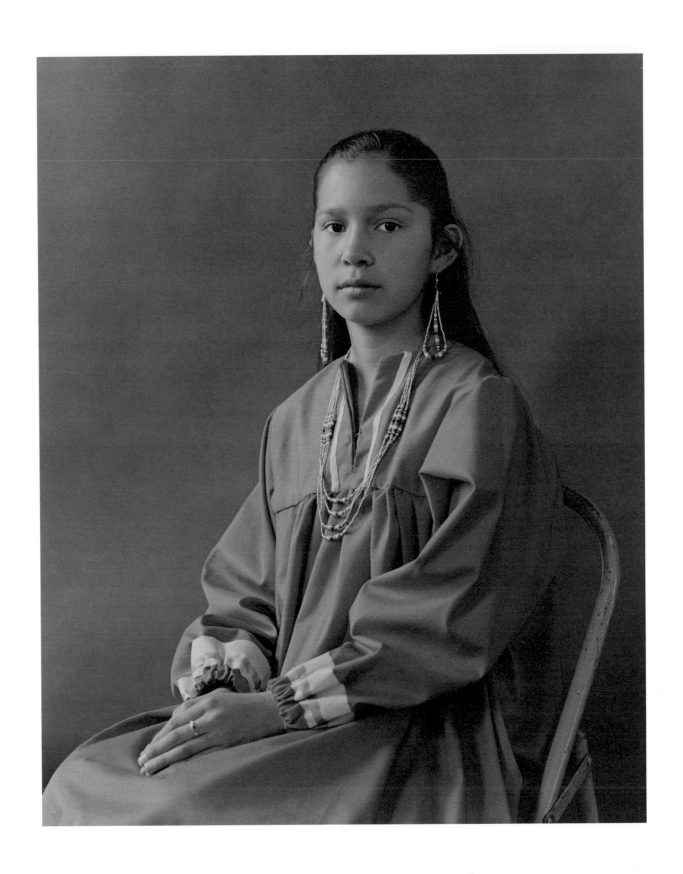

54

EMMA SHENANDOAH, Mohawk Wolf Clan

Tracy L. Shenandoah's daughter

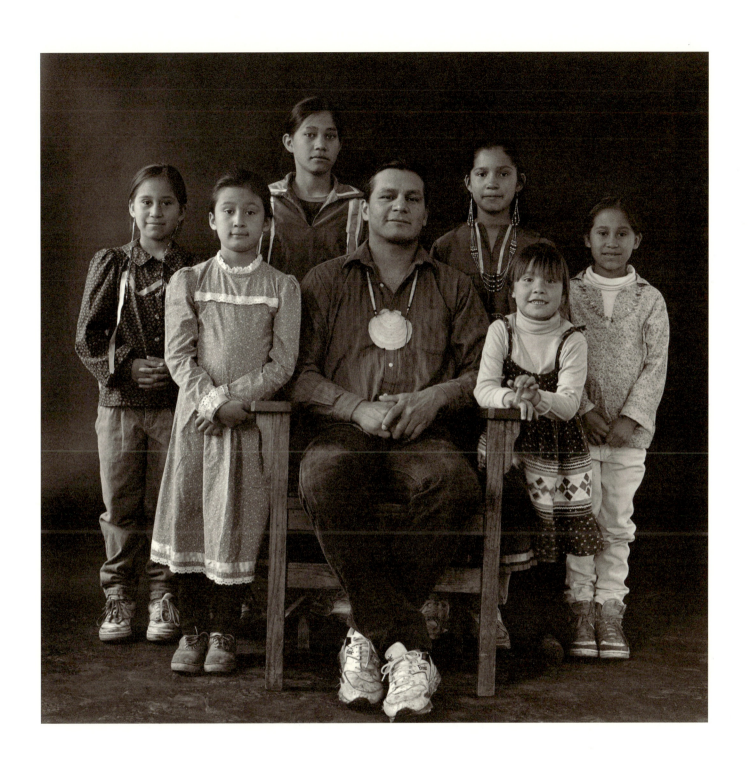

55

TRACY L. SHENANDOAH, Eel Clan, with children

JESSICA, SKASENIIO, SAM, EMMA, LENA, and Jessica's twin sister, ALICIA, SHENANDOAH, Mohawk Wolf Clan

Clan Mother Audrey Shenandoah's son and grandchildren

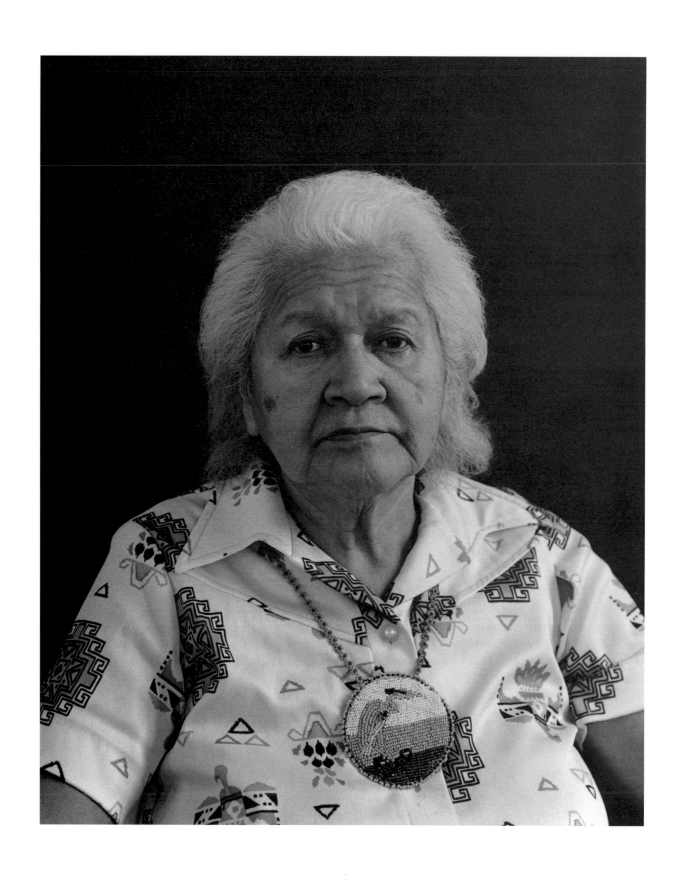

CLAN MOTHER HELENA M. CASEY, Heron Clan

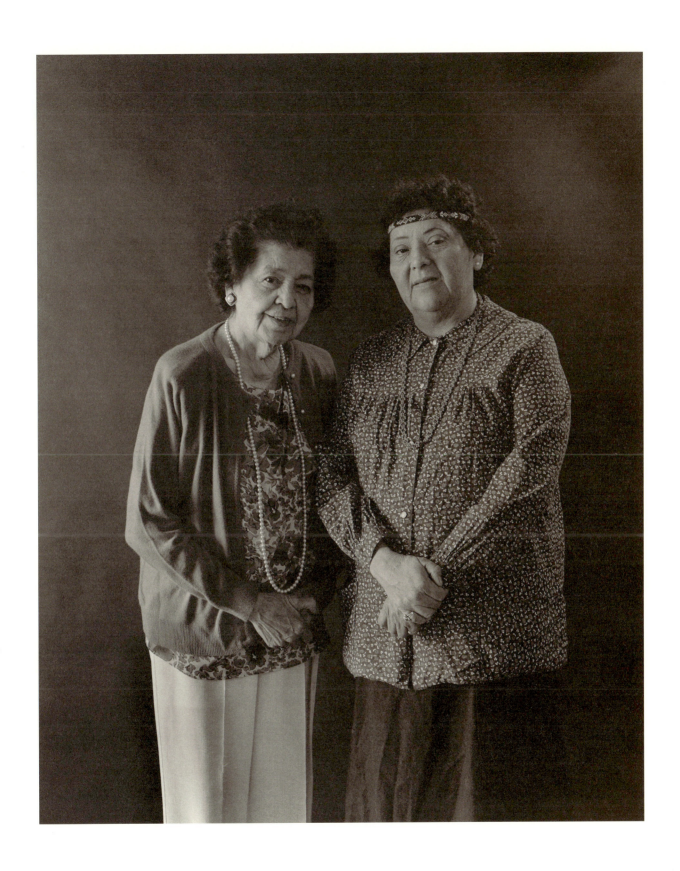

BERTHA DIMMLER with niece JACQUELINE COULON, Eel Clan

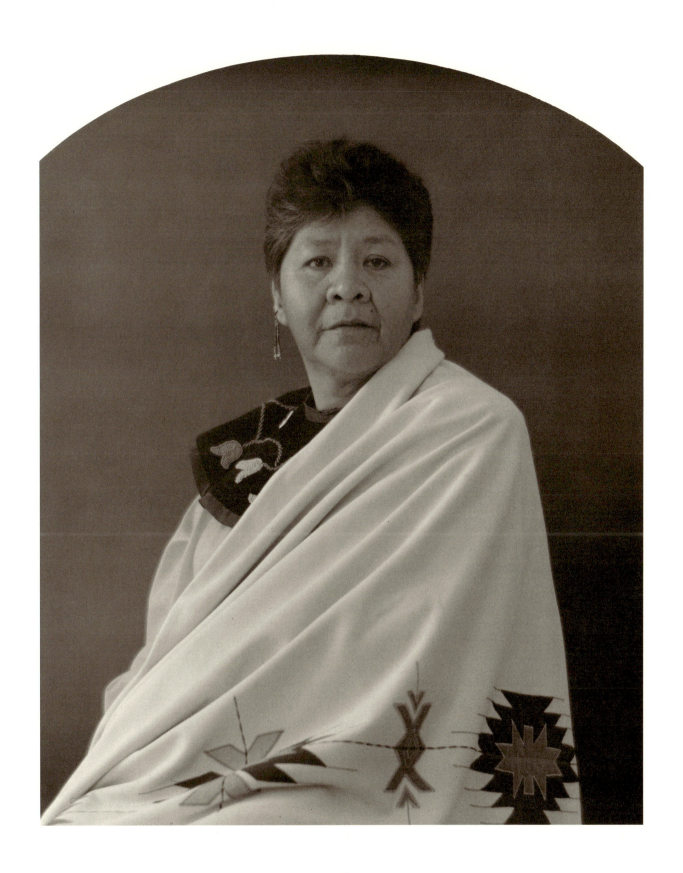

CLAN MOTHER BETTY JACOBS, Keeping Turtle Clan

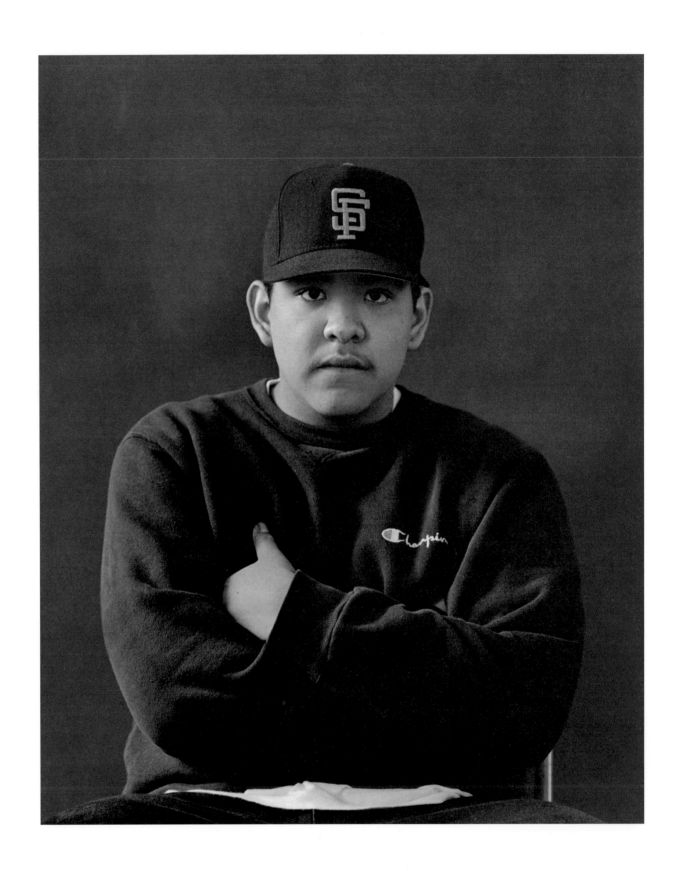

59

JESSE JACOBS, Beaver Clan

Clan Mother Betty Jacobs' son

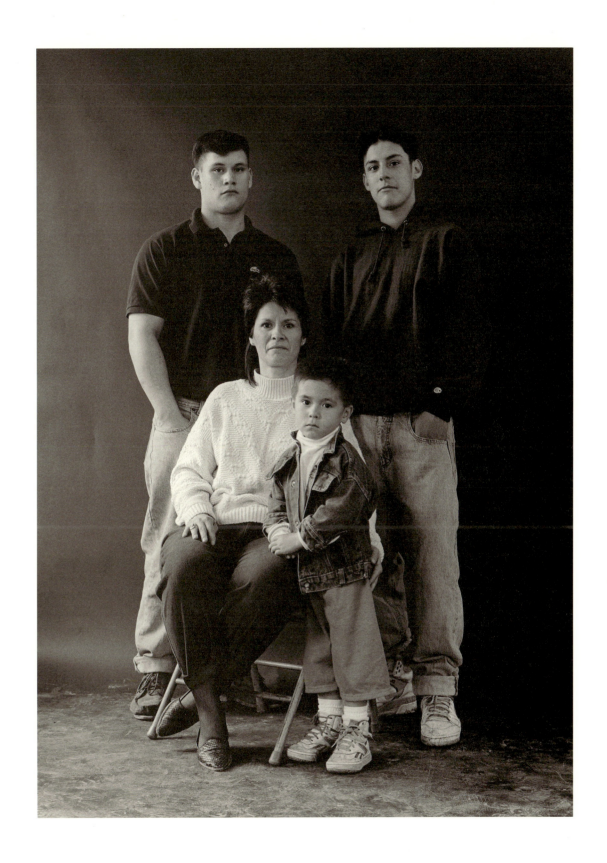

60

SHARON SHENANDOAH with sons EDWARD and PERCY SHENANDOAH
and WADE A. COOK, Mohawk Wolf Clan

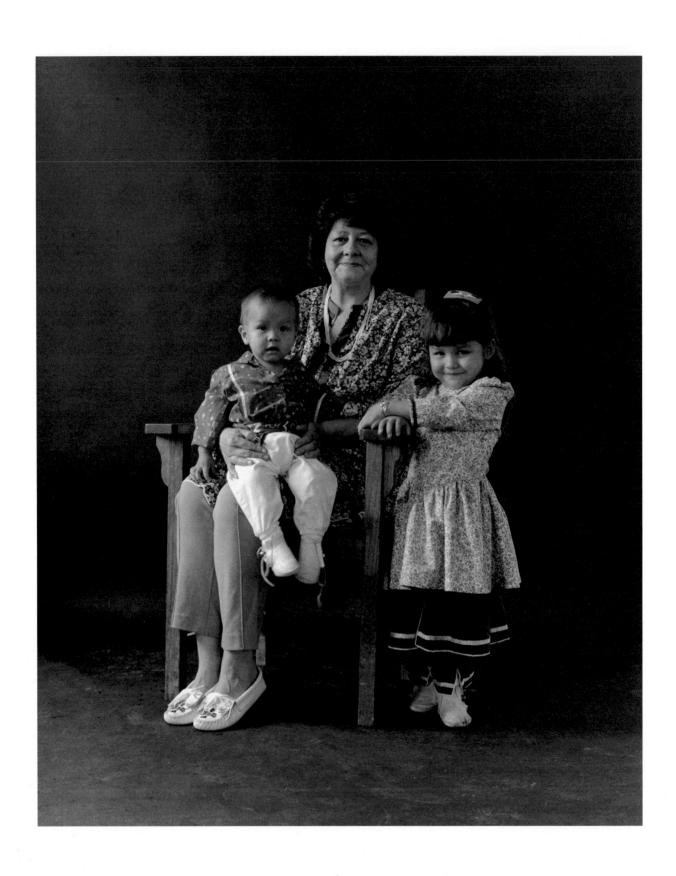

61

GERALDINE STEEPROCK with grandchildren

LYDIA BEA and VINCENT LAMONT THOMAS, Eel Clan

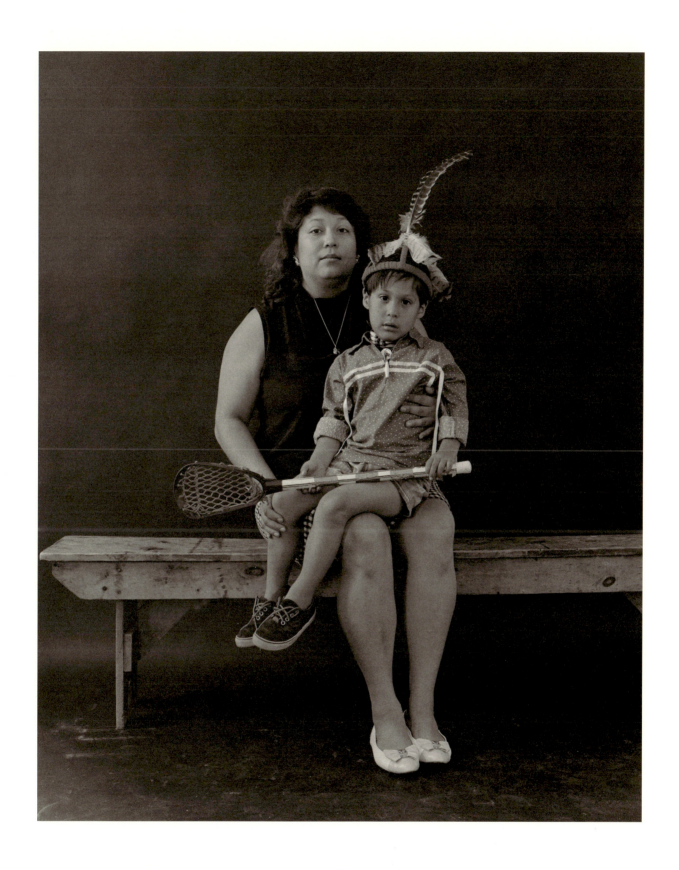

62

SUSAN LYONS with son LEE M. ANDERSON LYONS, Eel Clan
holding lacrosse stick

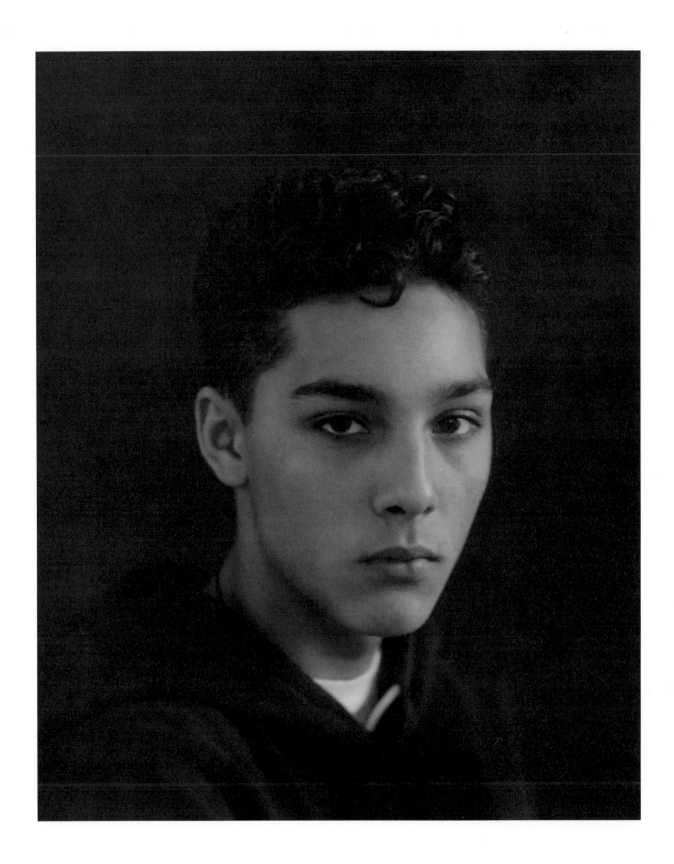

SHANNON BOOTH, Eel Clan

Charmaine Smith's son

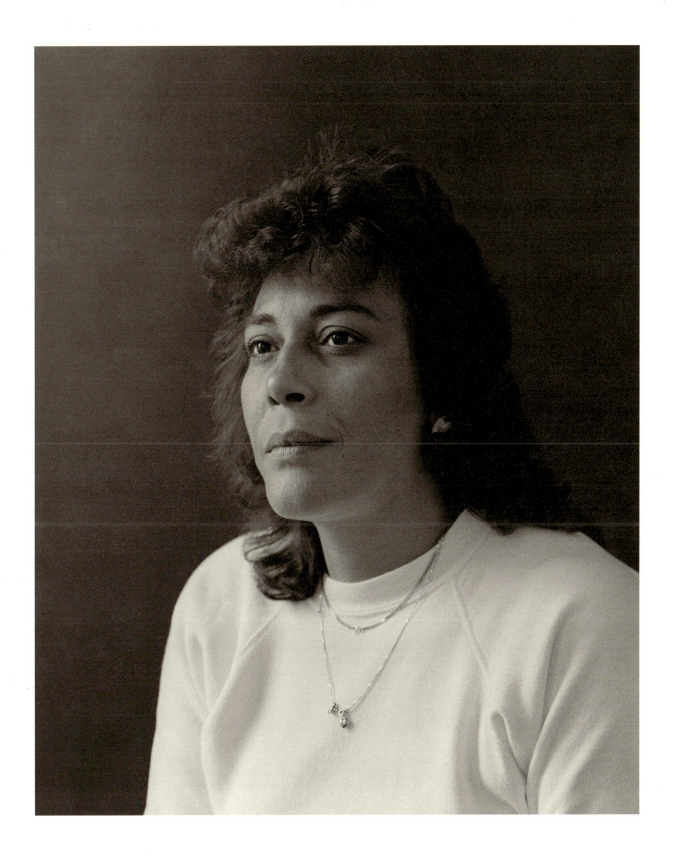

CHARMAINE SMITH, Eel Clan

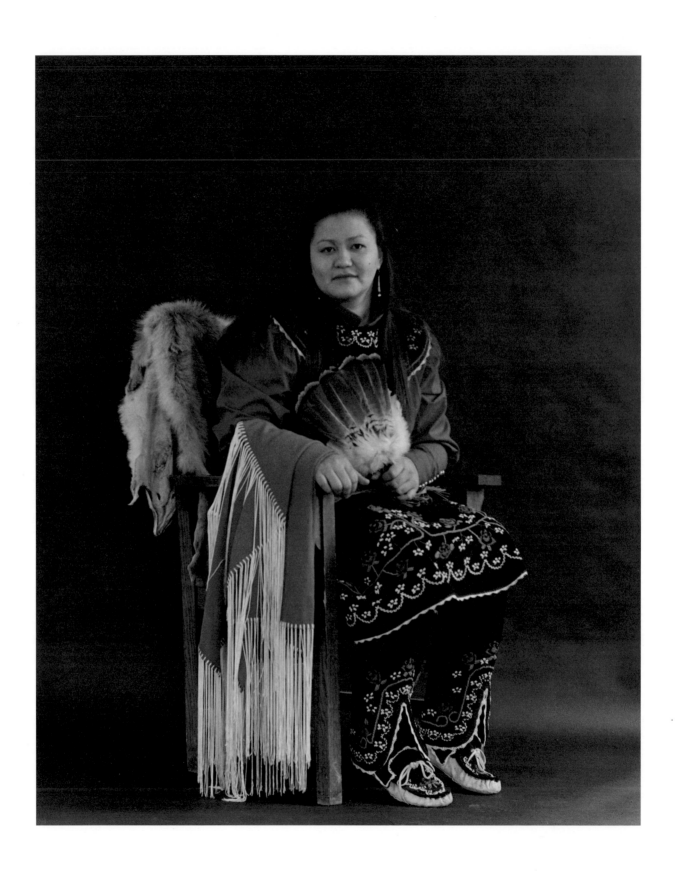

65

ALICIA A. COOK, Mohawk Wolf Clan

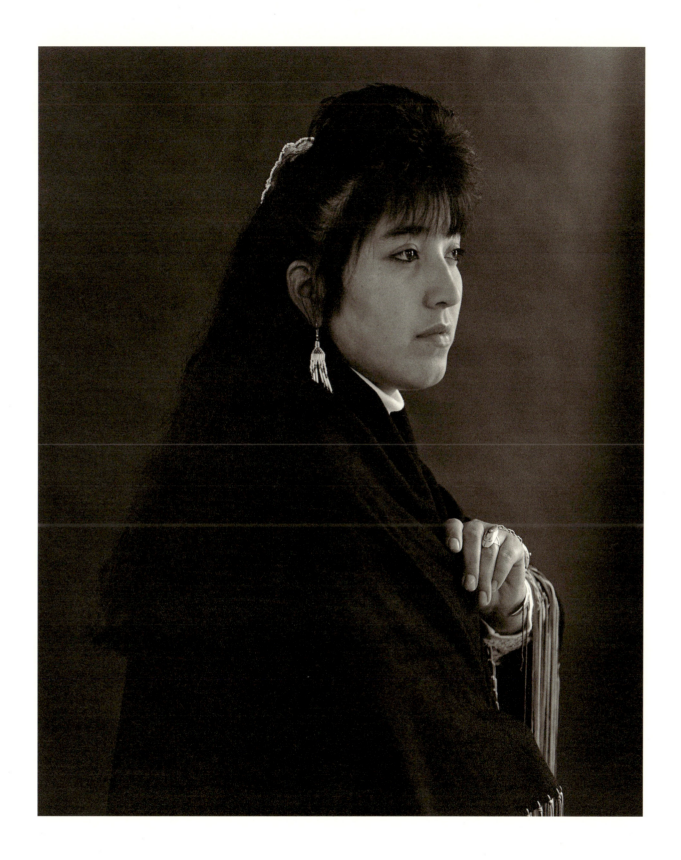

66

BRENDA COOK, Mohawk Wolf Clan

Alicia and Angus Cook's sister

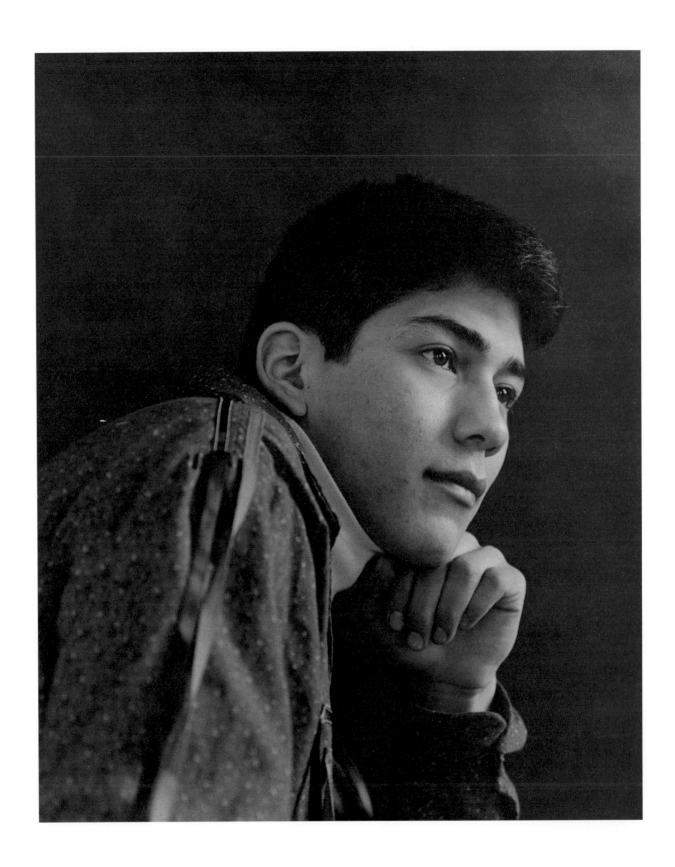

67

ANGUS COOK, Mohawk Wolf Clan

Alicia and Brenda Cook's brother

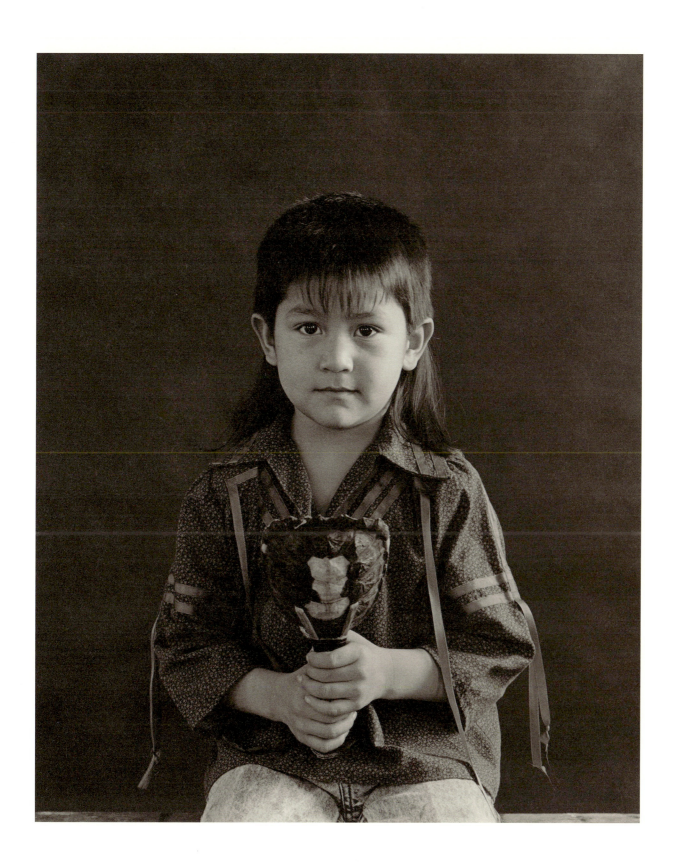

68

JOHNSON J. JOHN, Mohawk Wolf Clan, holding turtle rattle

Alicia A. Cook's son

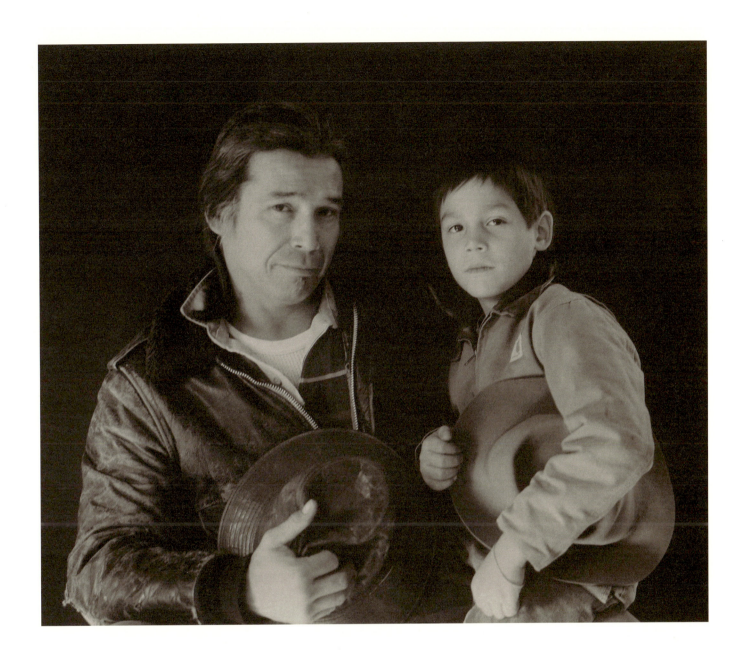

JOHN DEER, Beaver Clan, with son ALEX WILLIAM THUNDER DEER, Eel Clan

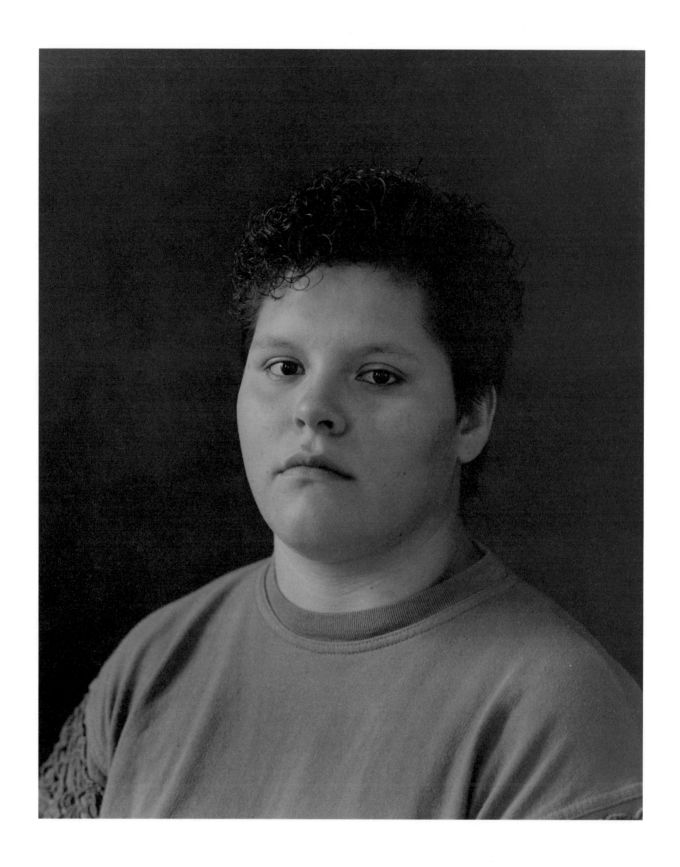

SACHEEN SHENANDOAH, Mohawk Wolf Clan

Paul Shenandoah's daughter

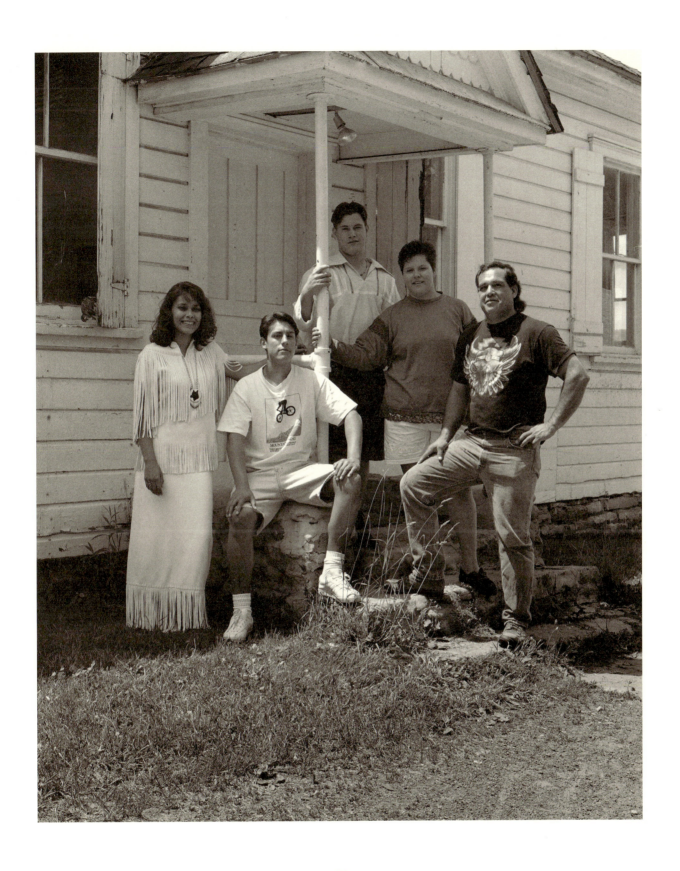

71

PAUL SHENANDOAH, Eel Clan, with children
AMY GIBSON, Wolf Clan, PERCY and EDWARD SHENANDOAH, Mohawk Wolf Clan
and SACHEEN SHENANDOAH, Mohawk Wolf Clan

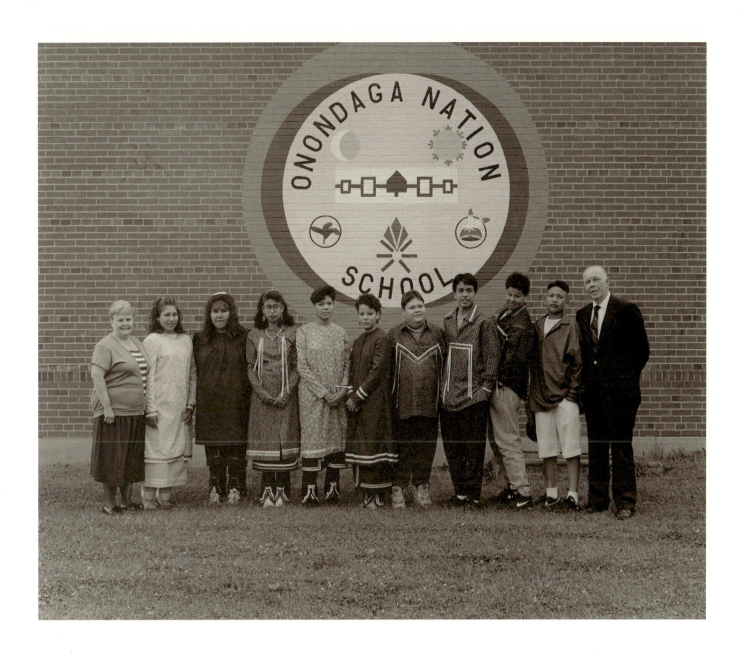

ONONDAGA NATION SCHOOL, GRADUATING CLASS JUNE 1992

Ken McCaffrey, Principal, Donna Young, Teacher

Students left to right: Dorothy Jocko, Wanda Winder, Tianausdi Shenandoah, Kimberly Homer,

Deena Webster, Brandon Crouse, Marshall Abrams, Brandon Isaacs, and Garrett Bucktooth

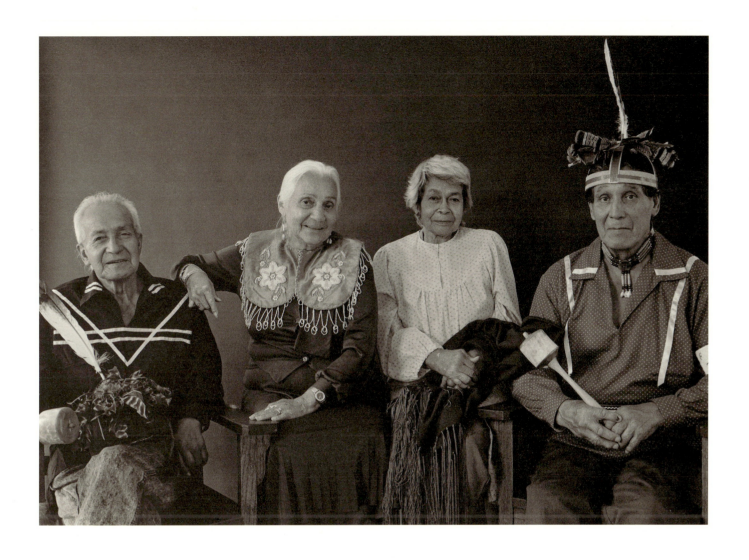

73

TOHDADAHO LEON SHENANDOAH

with brother EDWARD E. SHENANDOAH and sisters

CLAN MOTHER DEWASENTA ALICE PAPINEAU and FAITHKEEPER PHOEBE HILL, Eel Clan

ONONDA'GEGA'
ONONDAGA PEOPLE

We are the "People of the Hills"

This territory has embraced

And loved our people

For immeasurable numbers of winters

Our very name is

From an ancient time.

Here Ononda'gega' remain

Holding to the land.

Our Spirit Fires forever kindled

And nurtured

By the Ancient Ones

Who lived before us.

A legacy was left us

Venerable, unsurpassed, enduring,

Enduring the passages of time.

Here Ononda'gega' remain

Joined by sisters and brothers

Of like mind,

Sustained by the power within the Spiritual Teachings

And governance

From the long, long ago.

Here Ononda'gega' remain

We carry on and we survive

Grateful and indebted we are

To those generations before us

Whose resistance did not allow

Intrinsic original teachings

To be forgotten and lost.

Here Ononda'gega' remain.

GONWAIANNIH (Audrey Shenandoah)

ACKNOWLEDGMENTS

I ACKNOWLEDGE WITH GRATITUDE those mentioned here for their assistance, encouragement, and support of my work with the Onondaga Nation, and the resulting publication and exhibitions.

I am indebted to the Haudenosaunee and the people of the Onondaga Nation for joining me in creating a memorable document for their future generations, and for contributing to the visual history of America.

I wish to thank the Onondaga people who are portrayed here (as well as the many who are not), especially Audrey Shenandoah and her daughter Jessica Jeanne Shenandoah, whose guidance, advice, and friendship were invaluable. To Oren R. Lyons and Chief Irving Powless Jr., whose initial consent was necessary for the realization of my aspirations to photograph the Onondaga Nation, I offer my sincere appreciation.

I thank the Grand Marnier Foundation for funding this project. Michel Roux, Director of the Foundation, deserves particular thanks for his confidence in my vision, his unique imagination, and the generous support that brought this project into being.

I am grateful for additional funding granted by the Daniele Agostino Foundation for the completion of the project, including the final printing for exhibition.

Harold Feinstein inspired me and instilled within me the love of photography when I first began photographing. And to Toby Old, who encouraged me to make my first portraits, which included a Native American, I will always be grateful.

Special appreciation goes to Flavia Derossi Robinson for her warm friendship and generosity, and for the enthusiasm that often is a challenge in disguise; and to Robert Giard, whose photographs I admire greatly, for a long friendship during which we have shared our portrait-making experiences.

I am particularly pleased to acknowledge those who were especially supportive while working on this project: Helen A. Harrison, Julia Van Haaften, Linda Hackett Munson, George Steeves, Deborah A. Light, John Head, Marshall Robinson, Jeffrey Hoone, Joel Buchman, and Dennis J. Connors.

I also wish to thank the Friends of Historic Onondaga Lake, Light Work, the New York State Council on the Arts, the Everson Museum, Christopher Kuntze for the elegant design of this book, and the editors and staff of Syracuse University Press, most especially the director, Robert Mandel, and my editor, Nicole Catgenova.

TOBA PATO TUCKER is a documentary portrait photographer who has been recording continuity and change in American culture for two decades, working primarily with Native Americans. Her photographs are in the permanent collections of the National Museum of the American Indian, the Metropolitan Museum of Art, the Museum of Modern Art, the New York Public Library, and the Heard Museum, among others, and are exhibited in museums, libraries, and universities throughout the country. Recent books include *Pueblo Artists: Portraits,* and *Heber Springs Portraits: Continuity and Change in the World Disfarmer Photographed*. Her work has been published in *LIFE* and *Native Peoples* magazines.

This book has been printed in an edition of 1000 copies.
Composed in Aldus text type with Trajan for display.
Printed by The Stinehour Press, Lunenburg, Vermont,
on Potlatch Mountie Matte Natural 100# text stock.
Bound by Acme Bindery, Charlestown, Massachusetts,
with Scholco Brillianta cloth and Multicolor endleaves.
Book design by Christopher Kuntze.